Freehand Perspective
and Sketching

Freehand Perspective
and Sketching

DORA MIRIAM
NORTON

Dover Publications, Inc., Mineola, New York

Bibliographical Note

This Dover edition, first published in 2006, is a republication of the eighth (1925) edition of the work, originally published by the author, Brooklyn, N.Y., in 1908. The author's preface, revised for the second edition, has been omitted here.

Library of Congress Cataloging-in-Publication Data

Norton, Dora Miriam.
 Freehand perspective and sketching / Dora Miriam Norton.
 p. cm.
 Originally published: 8th ed. Brooklyn : D.M. Norton, 1925.
 Includes index.
 ISBN 0-486-44752-9 (pbk.)
 1. Perspective. 2. Drawing—Technique. I. Title.

NC750.N74 2006
742—dc22

 2005054779

Manufactured in the United States of America
Dover Publications, Inc., 31 East 2nd Street, Mineola, N.Y. 11501

TO THE

MEMORY OF WALTER SMITH

FIRST DIRECTOR OF THE MASSACHUSETTS NORMAL ART SCHOOL
INSPIRING CRITIC AND JUDICIOUS FRIEND

THIS BOOK IS DEDICATED

WITH THE WISH THAT IT MAY HELP OTHERS AS ITS
AUTHOR HAS BEEN HELPED

D. M. N.

CONTENTS

CONTENTS

INTRODUCTION

FREEHAND Perspective teaches those few principles or truths which govern the appearance of things to the eye, and the application of these principles to the varied conditions encountered in drawing. Strictly speaking, there are but two foundation truths in perspective, namely:

First. *Things appear smaller in proportion to their distance from the eye.* A house ten rods distant can be wholly seen through one pane of glass (Fig. 8, Ch. II).

Second. The eye can see surfaces in their true shape *only when placed at right angles to the direction in which the eye looks*, or, generally speaking, *parallel to the face.* When not so placed they appear lessened in one dimension, that is, either narrowed or shortened, in proportion as they are turned away from the face or tend to coincide

FIG. 1

with the direction of seeing. *This apparent change of shape is Foreshortening.* The cylinder top held at right angles to the direction of seeing appears as a circle (A in Fig. 1). When turned away from this direction (as at B), it appears narrowed, or foreshortened. So the pencil seen its full length at A in Fig. 2 appears foreshortened when held as in B. All the phenomena of freehand perspective, however complicated and perplexing, may be simplified by referring to one or both of these principles.

FIG. 2

One great obstacle to the ready mastery of these principles is our knowledge of the actual shapes of objects. For

instance, we *know* the top of a cylinder (B, Fig. 1) to be in fact a circle, and therefore we tend to mentally *see* a circle, though it is just as truly a fact that the top can only appear to the eye as a circle when the cylinder is held so as to lose sight of all other parts of it, as at A. Consequently, the first aim and benefit in studying perspective is *the learning to see;* that is, to know what is the image really presented to the eye. Therefore no step should ever be passed without clearly *seeing* the appearance under consideration. And in all drawings the final test must be the eye; for, unless the drawing *looks* right, it is not right. All rules and tests are only means to this end.

Furthermore, the right study of perspective, which is thinking and drawing in perfect coördination, enables the student to draw objects singly or combined or in unfamiliar positions, without having them in sight. Also he should be able to draw an object which he has never seen if a description of it can be supplied. That this last is quite possible any practical artist will agree. The writer recalls hearing a popular illustrator ask in a company of friends, "Does any one know what a cider press is like?" adding that he must put one in an illustration with no chance to see the thing itself. No doubt of the sufficiency of a description was expressed, and in this case it must suffice — a not uncommon situation. Hence the necessity of memory work and dictation problems, such as form part of this course of study.

Finally, it is not intended that in later practical work drawings should be actually constructed by the explanatory methods here given. These exercises should be drawn as directed, since only by the actual experience of doing it can their principles be mastered, but a rigid clinging to these methods in practice would result in very little art. Freehand Sketching means *drawing by the trained eye and judgment,* only using constructive methods to test new or doubtful points. It is to make such sketching valuable by a foundation of definite knowledge that these methods

are given. The trained artist draws a vase in his flower study, or a round tower in a landscape with no distinct recalling of ellipse laws, feeling only joy in the living curves as they spring out under his hand. But he would labor long and wearily over their shaping had he not this foundation knowledge, which he uses almost unconsciously.

Chapter *I*

GENERAL DIRECTIONS

MATERIALS. — Any paper having a fine and fairly soft texture can be used. It should produce an even grain in both vertical and horizontal pencil strokes. Pencil exercises such as those reproduced in this book are usually drawn on paper of quarter imperial size (11″ × 15″), on which at least an inch and a half of margin is allowed. This is a good size for the student's drawings, whether copied from these exercises or drawn from objects. Have two pencils, one fairly soft (as No. 2 Faber, SM Dixon, or 2 B Koh-i-noor), and a harder one; also a good eraser.

Line Practice. — Cut the pencil like the illustration (Fig. 3), and rub on practice paper[1] till a broad line, firm at the edges and transparent (that is, with the grain of the paper slightly showing through it) can be made. Sit erect, with the paper directly in front, and have the desk top inclined, or use a drawing board (Fig. 4), that the paper may be as nearly as possible parallel with the face. Hold the pencil almost flat, as in the illustration (Fig. 5), and as loosely as is consistent

FIG. 3

FIG. 4

[1] Save spoiled sheets for this. Practice paper should be like that on which drawings are made.

with a steady control. For horizontal lines use position A, Fig. 5, moving the pencil from left to right; for vertical lines use position B, moving from the top downward. Practice vertical, horizontal, or oblique lines persistently; moving the hand freely from the shoulder, not resting it on the wrist or

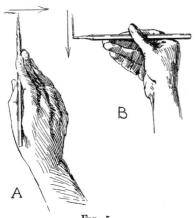

elbow. If the muscles acquire an unpleasant tension, relax by dropping the hands at the sides and loosely shaking them. Unfamiliar or difficult exercises should be first carefully sketched with a thin, light line. If wrong, draw over without erasing until a satisfactory form is obtained. Erase the incorrect part, and render expressively (Ch. IV). But after the composition of the exercise is planned, such straight lines as mar-

FIG. 5

gins, cylinder sides, and many ellipses may be drawn in full at once. And as the student gains in skill, more and more of the work should at the first touch be put on the paper as it is intended to remain. Exact knowledge is to be acquired only that artistic interpretations may be expressed with ease and certainty.

Models for Work. — Objects in common use have been chosen for most of these exercises. Geometric solids are assigned only as needed for the clearer elucidation of perspective truths. Necessary models, as the cylinder, the cube, and others, should be made by the student as directed. For forms (as the hexagonal frame) too complicated to be easily made, the well-known wooden models have been used. But after thorough mastery of the simpler forms, most of the later lessons can be understood without models.

Placing of Models. — All objects for study should be placed so as to present their vertical surfaces in nearly their true shape to the student. Thus if the model is to be near, as on the table

at which the student sits, it is better to raise it a few inches (Fig. 4). This will not be necessary if it can be placed four or five feet distant. If the study is seen too much from the top, the perspective will be unpleasantly violent, as in a photograph where the camera has been pointed too much downward.

The Table Line. —To indicate a supporting surface under the objects a horizontal line (A, B in Fig. 6) is used. It stands for the back edge of the table or other horizontal support-ing surface, and is called the Table Line. It should be represented as further back than any portion of the study. As will be observed later, it need not be used if the supporting surface is otherwise suggested, as by a cast shadow (Fig. 34).

FIG. 6

All Work Freehand. —All work is to be done freehand, that is, with no ruling, and no measuring other than by the eye and pencil.

Chapter II

PENCIL MEASUREMENT AND THE PICTURE PLANE

PENCIL Measurement. — Before studying the exercises which follow, the beginner should become familiar with Pencil Measurement. Place a book upright directly in front of the eye. With one eye shut and the arm at full length (to ensure a uniform distance from the eye) measure on the pencil held horizontally the apparent width of the book. Then turning the pencil, compare this distance with its height (Fig. 7). (It is better to take the smaller distance first, and to measure it into the larger.) Compare the proportions so found with those obtained by actual measurement of the book. But always get the pencil measurement first, for this compels the eye to do all that it can unaided before showing by actual measurement how much better it can learn to do.

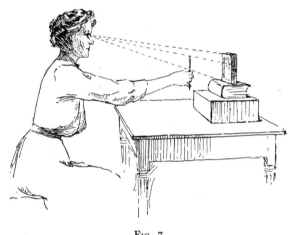

Fig. 7

Now turn the book away a little, and compare this new appearance of the width with the height (Fig. 12).

The Picture Plane. — Here we must learn to *keep the pencil parallel with the face* in order that the pencil measurement may be reliable. For this, go to the window, and stand facing

4

the glass, so the face is parallel with it. Choose some object seen through the window, as another house, and resting the pencil against the glass measure its width and compare that with its height (Fig. 8).

Observe that if the outline of the house could be traced by the pencil on the glass it would form correctly the apparent shape of that house.

This leads us to see that *all perspective drawing may be regarded as placing on paper the equiva-*

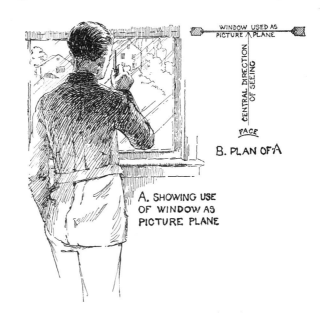

WINDOW USED AS PICTURE PLANE

CENTRAL DIRECTION OF SEEING

FACE

B. PLAN OF A

A. SHOWING USE OF WINDOW AS PICTURE PLANE

Fig. 8

lent of such a tracing on the glass. It will therefore be apparent at once that pencil measurement, to be correct, must be taken with the pencil held as if laid on such a pane of glass; or in other words, *on a plane parallel with and in front of the face.* This imaginary transparent plane is called the Picture Plane, and is a most important factor in all freehand drawing. Thus, by turning or revolving the pencil on the glass in front of the face, that is, by revolving the pencil in the picture plane, *it can be made to cover the appearance of any possible line or direction.* For example, the sloping gable edge of the outside house, though retreating from the eye and therefore foreshortened, can be covered by the revolving pencil (Fig. 9), thus giving

Fig. 9

the appearance or picture of its direction. Its apparent or fore-shortened length can also be taken on the pencil and compared with any other dimension, as the height of the nearest corner. The essential requirement is *that the pencil shall constantly lie flat on this pane of glass; that is, on the picture plane.*

We have therefore, in the use of pencil measurement on the picture plane, a ready and accurate means of ascertaining any direction or any proportionate dimension seen by the eye. It cannot give us *actual* sizes, as the length of the gable in feet; but it will tell us how long the slanting line representing the gable must be drawn *in proportion to other parts of the house.* In this case, for instance, the sloping edge appears three-fourths of the gable width. The difficulty in using this valuable aid with exactness lies in the beginner's trouble in keeping the pencil always in his invisible picture plane. Any distance between the eye and the object may be assumed for the picture plane. But for accuracy this assumed distance must be kept the same while comparing sizes. This is easily done by sitting erect and measuring at arm's length, supporting the elbow with the other hand if needful. The student should then *mentally see* the picture plane, recalling that it is *vertical,* or *parallel with the face* when looking at the middle of the objects to be drawn. That is, it is at right angles to what we may call the Central Direction of Seeing.

The Central Direction of Seeing. — This extends from the eye to the center of the objects observed, while the face and the picture plane are parallel to each other and at right angles to it. The picture plane may then be thought of as a transparent vertical plane pierced in its middle by the direction of seeing.

We have said the central direction of seeing is at right angles to the face. Since the face is generally vertical, the direction of seeing is generally horizontal (A in Fig. 14, Ch. III). The commonest exception is that of being directed slightly downward (B in same Fig.). In this case it cannot be at right angles to the picture plane. It will, however, always *appear* at right angles to

it *when looked at from above.* That is, it is *at right angles from side to side,* and in a plan will always be shown at right angles, as in Fig. 8.

Return now to the seat (Fig. 7), and try pencil measurement on the turned book. Imagine as clearly as possible the trans-

parent picture plane at arm's length, on which the pencil may be revolved, but through which it must never be thrust. Starting with the pencil erect (Fig. 10) drop it directly over to the left (Fig. 11), watching carefully to keep it from leaning back or forward. Let another person help by turning the book away while you measure it and at the same time

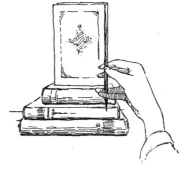

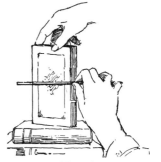

keep the pencil from following it back-ward as it is turned away (Fig. 12). Thus as the book is turned, the pencil, if it remains on the picture plane, shows the book to appear narrower or be fore-

shortened. What is now sought for is that which the

FIG. 11

eye really *sees* as the width, not what the mind *knows* it to be. It is of great im-portance to distinguish sharply between *actual facts* of form and size and *the per-spective appearance of them as presented to the eye.*

FIG. 12

An excellent object for practice is a door. Stand facing a closed door, and take its proportions by pencil measurement. Then let some one open it, and observe the apparent decrease in width.

For further consideration of the picture plane see Chapters XXXIV, XLI, and XLIII.

Chapter III

THE ELLIPSE

HAVING learned that the book cover and door appear foreshortened in proportion as they are near to coinciding with the direction in which they are seen, we naturally look for the same change in the Circle.

Making a Cylinder.—Fold the long edges of a piece of stiff paper (A in Fig. 12a) and roll it into a cylinder, tucking one end of the paper under the folds of the other (B in Fig. 12a).

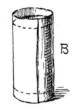

FIG. 12a

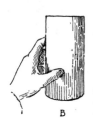

Seeing the Ellipse.—Holding the cylinder vertically, as in A, Fig. 13, and with one eye closed, raise it slowly till on a level with the eye. The top now appears as a straight line (B, Fig. 13). It is so foreshortened that its surface is entirely lost to sight, leaving only its edge visible. Now, keeping the cylinder vertical, lower it till the eye sees into it perhaps half an inch. Observe carefully the shape formed by the top. Turn it so the top appears as a circle (A in Fig. 14),

FIG. 13

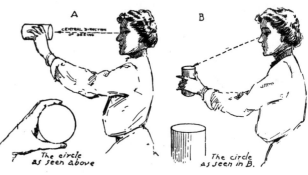

FIG. 14

then, holding it vertically again (as at B), compare mentally the apparent shapes as the top is placed in the two different positions. Now (keeping it always vertical) raise and lower the

8

cylinder slowly, and note how the form of the top changes, appearing rounder as it is lowered.

Symmetry of the Ellipse. — This peculiar shape, varying in roundness between the straight line and the circle, represents *the appearance of the circle seen obliquely,* and is *the Ellipse,* one of the most beautiful, spirited, and subtle of curves. While the circle is formed by a curve bending equally in all parts, the outline of the ellipse is constantly changing in the degree of its curvature. From the middle of each side (A, A in Fig. 15) this curvature increases smoothly to the

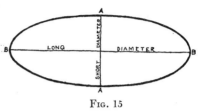

FIG. 15

ends (B, B). Thus the ellipse may be divided by lines through the middle of its sides and ends into four duplicate curves or quarters. These lines are known as the Long and Short Diameters. On these two lines the ellipse must be symmetrical, whatever the proportion of the diameters to each other; that is, whatever the roundness of the ellipse.

Testing the Ellipse. — A test useful to determine the correctness of a drawing of the ellipse is sighting with one eye along the long diameter. If the ellipse is perfect it will appear foreshortened to a circle having a diameter equal to the short diameter of the ellipse. But there is no test of the ellipse like the ellipse itself as seen in objects. The student should compare his drawing of ellipses with the rhythmically varying curves which compose ellipses as seen in real objects, correcting and comparing till the eye is satisfied. If this be faithfully done, the time will be short before ellipses, often deemed a bugbear of freehand drawing, become a pleasure instead of a penance.

Roundness of Ellipses According to Position. — Since the top ellipse appears rounder as it is dropped below the eye level, it must be concluded that could the bottom be fully seen it would appear as a rounder ellipse than that of the top. Place the cylinder on the table and trace around the bottom with a pencil. Move the cylinder to one

FIG. 16

9

side and compare the shape of this traced ellipse with that of the top ellipse (Fig. 16). Also compare both with that part of the cylinder bottom which can be seen. There is no difficulty in perceiving that the ellipses in a vertical cylinder below the eye are rounder as they are farther below the eye level.

Now, keeping the cylinder vertical, raise it slowly. When the bottom ellipse reaches the level of the eye, it appears as a straight line (A in Fig. 17), like the top ellipse when at the same height. When the cylinder is moved on above the eye, the bottom becomes an ellipse (B), which as we raise it farther above the eye level appears rounder. We perceive that it appears rounder or less foreshortened in proportion as it is farther from coinciding with the direction in which the eye looks to see it, as was the case with the book cover in Chapter II. Furthermore, if the cylinder be turned horizontally and held at the level of the eye with its length parallel to the picture plane, and one end be brought in front of the eye, we shall again see this circular end as a straight line (B in Fig. 18), because it coincides with the direction of seeing. If the cylinder be moved horizontally to one side, still keeping its length parallel

FIG. 17

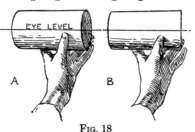

FIG. 18

with the picture plane (A in Fig. 18), the ellipse appears to widen exactly as when the cylinder was held vertically and moved above or below the eye level. The circular top appears as a circle only when its surface is at right angles to the direction of seeing (A, Fig. 14). When oblique to this direction, as at B, it appears as an ellipse, or foreshortened circle. The ellipse is plainly, therefore, an illustration of the second great principle, that of Foreshortening.

Practice of Ellipses. — The student should now practice drawing ellipses, both vertical and horizontal, until they can be formed

with ease and exactness. Mark the extreme points (A, A, B, B, Fig. 15) first taking care to have B B exactly opposite the middle of A A. Hold the pencil for drawing ellipses as directed in Chapter I for straight lines, using a position of the hand that will bring the pencil at right angles to the long diameter. If the ellipse is horizontal, begin it a little to the left of the middle of the upper side, drawing to the right first. If vertical, begin below the middle of the left side, and draw up. Make the whole outline with one movement, first carrying the pencil evenly several times over the paper without touching it, to gain confidence and certainty of movement.

Chapter IV

A CYLINDER AND A CYLINDRICAL OBJECT

THE student should draw this exercise, following carefully the directions given. After doing so he should draw a cylindrical object of his own choosing, putting in practice the principles taught in this chapter.

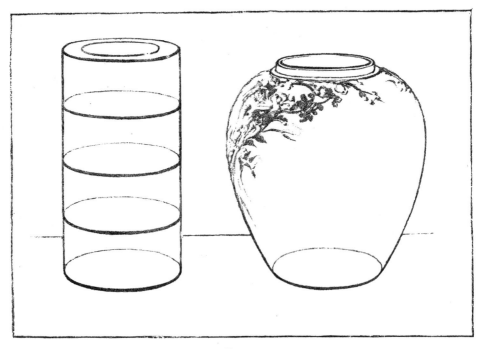

FIG. 19

Planning the Drawing. — The Design, or Composition, or Decorative Arrangement of the exercise, which is that kind of beauty secured by a harmonious and artistic relating of the work and its spaces, is to be considered first in all drawings, and should always be kept in mind. For this exercise (Fig. 19) we first consider how to place most effectively in a drawing these two separated

objects, a cylinder whose height is twice its width and some simple cylindrical object (in this case a rose jar). To this end after drawing the margin the extreme points in the boundaries of the objects are lightly indicated on the paper (Fig. 20), taking care that the spaces between them and the margin are such as to

FIG. 20

give an agreeable and interesting division of the inclosed surface. The continuous table line behind them indicates that they stand on the same surface, and thus links them together. The size of the space between them, being no more than that between either and the side margin, also helps unite them; and the position of the ornament on the jar, near the middle of the sheet, attracts the eye to the center in comparison with the whole.

Drawing the Cylinder. — For this the paper cylinder model used in Chapter III is placed as shown in the illustration (Fig. 19), that is, a little below the eye level, and at least six times its height from the eye. The apparent proportion of the top (that is, if the width of the ellipse appears to be one third, one fourth or some other part of its length) should be carefully judged by the eye and then tested by pencil measurement. Four points for this ellipse should then be lightly marked, and it should be drawn through these points as previously directed. The bottom ellipse is sketched directly under the upper and in the same way, remembering that it must be of the same length, but rounder. The back or invisible part of each ellipse is left light. The straight lines for the sides must be tangential to the ends of the ellipses, so they will join with perfect smoothness. If they do not thus join, the ellipse is the part most likely to be wrong.

Now is the time to put the drawing back by the paper model and compare the two. Look longest at the model, glancing briefly at the drawing; the aim being always to form in the mind a clear image of the model's true shape, and to correct the work by it. The student should ask himself if the cylinder in his drawing appears to press evenly on the ground like the model. The com-

13

monest error is that of bending the outline of the partially visible ellipse too much at A in Fig. 21, and not increasing the curvature

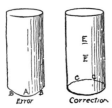

toward its ends (B, B), thus making the curve more circular than elliptical, and causing the cylinder in his drawing to look as if it would rock on its base, instead of resting firmly on every part of it. Sketching the ellipse entire (C, C) is an aid in such a case.

FIG. 21

Next a pencil line is drawn around the paper cylinder half way between the top and bottom. Points (E, E, Fig. 21) are then marked on the drawing, one half way between the fronts, and the other half way between the backs of the ellipses. These points should be tested after marking and made correct, but never measured till the eye has been made to do its utmost. Observe that these marks give a short diameter for the middle ellipse half way in size between those of the upper and lower ellipses.

In the same way the two other lines around the cylinder may be made on the model and represented in the drawing.

Now another paper cylinder, of the same length as the first but only two thirds its diameter, must be made, and placed within the first. Have the space between them even all the way around, so that the circular tops of the two cylinders form concentric circles. They appear as ellipses. Observing carefully the space between these ellipses, the student easily sees that it appears widest between the ends, and a little wider between the front sides than between the back sides. As we made the inner cylinder two thirds of the diameter of the outer, the horizontal space between the ends of the two ellipses will each be act-

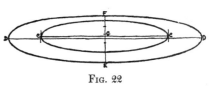

FIG. 22

ually made one sixth of the length of the outer ellipse. They will also *appear* as sixths, because the ends of the ellipse are equally distant from the eye. The ends of the inner ellipse (C, C) are marked by light vertical lines. For its front and back we divide

14

the width of the outer one also into sixths, but as these sixths are in perspective or at varying distances from the eye, they are *perspective* sixths. That is, *they appear successively smaller as they recede from the eye.* This perspective division is here made wholly by the eye (though later another method is given). The perspective middle (point G) is first marked on the short diameter, making the near half considerably larger than the far one. Each perspective half is then divided into perspective thirds, after which the six divisions are tested to see if they are successively smaller, as directed above. Draw the inner ellipse, making its ends tangential to the vertical lines (C, C), and exactly opposite the middle of its short diameter. It will now be found, if we draw the long diameter of each of these two ellipses where it must always be, *in the apparent middle from front to back*, that the long diameter of the inner one falls higher on the paper than that of the outer one. From this we conclude that neither long diameter represents the actual diameter of the circle. Fig. 23 shows the plan of a circle with its true diameter, A A. The eye at x sees B B, a line connecting two tangentials, as the longest line in that circle. It therefore becomes the long diameter of the ellipse which the eye in that position sees. Meanwhile the actual diameter appears both shorter and farther back than B B, because farther away. That part of the circumference back

Fig. 23

of B B, though actually larger, is so foreshortened as to appear exactly like the part in front, producing the symmetry which is the wonderful and unfailing characteristic of the ellipse.

Since the inner circle is smaller, the eye can see farther round it, as shown in Fig. 23. This furnishes another reason for its long diameter falling farther back, and agrees with the fact that the really even space between the two circles appears greatest in front.

The Rose Jar. — For the second object proceed as with the cylinder, drawing lightly all of the ellipses entire first. Should

15

any fall at the same height as one on the cylinder, it must be made of the same roundness, since the two objects are shown by the table line to be on the same surface, and are equally near

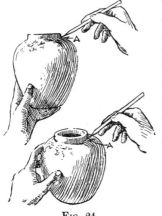

the eye. Compare the size of the ellipses with the extreme width of the space occupied on the paper by the jar. Compare also the lengths of the top and bottom ellipses, and the length of each with the extreme width of the jar. Observe that the sides of its short cylindrical neck slope outward slightly toward the body of the jar.

The Shoulders and Base of the Jar.—Before drawing the side outlines, hold the jar vertically at arm's length, and with the top on a

FIG. 24

level with the eye. Mark the point (A in Fig. 24) where the body and neck boundaries meet. Holding this point, lower the object till the top appears as a fairly round ellipse. It will be plain that we now see a portion of surface beyond the end of the ellipse, and more than half way over its shoulder. The boundary line which marks the limit of our seeing has moved back

on the shoulder, so that it passes out of sight behind the neck. A little experimenting shows that the surface visible beyond the end of the ellipse is in exact proportion to the roundness of the ellipse.

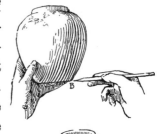

Now place a sheet of paper on the table, and first holding the jar so its base is on a level with the eye (Fig. 25), mark the extreme point of the base, B. Lower the jar slowly, till the bottom rests on the paper. Mark point B on the paper and then the points (C, C) where the side

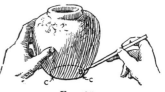

FIG. 25

boundaries now appear to meet the bottom ellipse. Trace around the bottom and lift aside the object. It will be found that the projecting mass of the jar, being nearer the eye than

the ellipse, had hidden from sight more than half of it. It is also evident that on the lower and receding part of the jar the boundary line advances, so that we see less than half of the surface, instead of more, as at the top. If we now trace on the jar its boundary line and turn it around, the tracing will be seen to cross the object obliquely (Fig. 26). With these facts in mind, complete the drawing of the rose jar.

FIG. 26

Tangential Joinings. — *All meetings of boundary lines with ellipses must be tangential.* That is, they must touch so that if smoothly continued they would not cut the ellipse.

Artistic Rendering. — The jar should be first drawn with thin light lines, corrected to accuracy, and afterward rendered with significance. For though outlines are entirely conventional, never being seen in nature, yet they may not only be made to mark off beautiful and interesting shapes, but by their character to suggest other truths and qualities for the enhancement of charm. Thus in the rose jar the front edge is shown to be nearer than the back by the heavier line, and the rounded thickness of the top is indicated by the absence of nearly all of the inner ellipse at the back and of the outer one at the front. The sides are drawn with a little lighter lines at the top, and though firm enough to clearly present the shape of the jar, are lighter than the front part of the top, because representing a part of the jar further from the eye.

The ornament may help to express the rounded form of the jar by its foreshortened shape as it nears the boundary, and by the greater clearness and emphasis of that portion of it most thrust forward. Its outlines, emphasized on one side, with the other side light or lost, and the detail shown in the side lines of the jar, indicate it to be in relief. The expression of color in places is used to strengthen the projection of the jar.

These remarks, however, must not be understood as rules. They are but suggestions for the incitement of the student to use his own artistic judgment.

17

Chapter V

AN OBJECT ABOVE THE EYE AND THE CONE PRINCIPLE

THE electric lamp shade here shown (Fig. 27) is vertical and above the eye, and its ellipses therefore increase in roundness toward its top. The student should draw this exercise, and make another study from some object similarly placed.

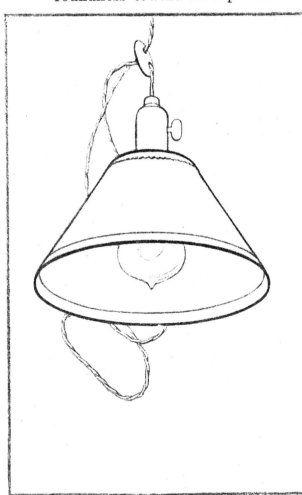

Drawing the Object. — Proceed as in the previous exercise. Observe that the sloping side boundary lines of the shade join the ellipses in front of their ends. The flaring shade is like the lower half of the rose jar reversed. Its smaller part is farthest from the level of the eye, as was the base of the rose jar, and we therefore do not see half way round it. To make this clear, hold a cone[1] in various positions

FIG. 27

[1] One may be made from paper (Fig. 28).

18

(that is, above and below the eye), and with apex up and down (Fig. 29).

The button through which the cord is drawn forms an oblique ellipse. But by turning Fig. 27 so as to bring this ellipse horizontal, the button will be found symmetrical on its axis (see Ch. XXVII); and as it is arched or thickened in its middle, the space in front of the holes

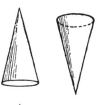

for the cord appears a good deal wider than that back of them. Each side of the button is a very flat modified cone. Notice in the outline of the cylinder the slight depression marking where the key enters its side.

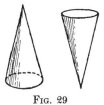

Fig. 29

It may be now noted that *when the cone apex* (that is, its decrease of diameter) *is nearer the eye than its base, we see more than half way round it.* Conversely, *we see less than half way round when the apex is farther from the eye.* This characteristic of curved or sloping surfaces in cylindrical objects may be termed *the Cone Principle.* Broadly speaking, it is *the expression, by outline merely, of Relief, or Solidity, or Third Dimension.* The rose jar in Chapter IV, the cream jug in Chapter VI, and indeed all cylindrical objects with flaring or bulging sides, are examples. More advanced applications of this principle are found in the drawing of such natural objects as trees and mountains, also in drawing the human face and figure.

Chapter *VI*

A CREAM JUG

THE Model. — Provide an object similar to the cream pitcher here shown (Fig. 30), from which the student's drawing should be made. If inexperienced he will be helped by first making a copy from this example.

The Handle. —Place the jug a little below the eye (according to the directions in Ch. I). Draw the cylindrical body entire first as if it had neither handle nor spout, and with light lines (Fig. 31). Then hold the model with its center at the level of the eye and with the handle in profile (A in Fig. 32). Observe that a center line for the joining of the handle with the model would fall in the curved boundary line or profile of the jug. Turn it to bring the handle directly in front, when this same center line (x in Fig. 32) will appear straight and vertical. Now, turn the jug slowly back, bringing

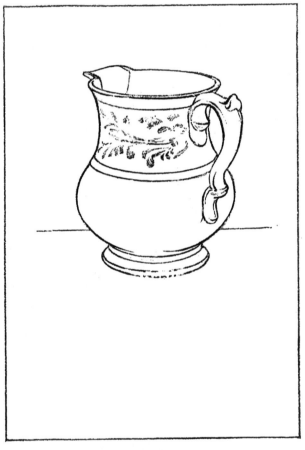

Fig. 30

the handle again into the boundary line. It is apparent that as the handle revolves, its center line of joining changes in appearance from a straight line in front through a succession of curves that increase in roundness till at last it coincides again with the profile of the jug (C in Fig. 32). These curves are lines such as would be produced on the surface by cutting vertically through the jug cen-

Fig. 31

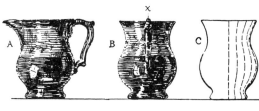

Fig. 32

ter, as an apple is halved; and may be named Profile Lines or Profiles.

Replace the model on the table and revolve the handle to the side again, when it will be seen that the ends of these profile curves rest on the top and bottom ellipses of the jug (Fig. 33). And the side boundary of the jug does not now coincide with the profile at the side, as it did (A in Fig. 32) when the jug was held at the eye level. This is because of the change in the position of the boundary. As the jug is placed below the eye the boundary advances from A to B, recedes from B to C, and advances again from C to D, in accordance with the cone principle (Ch. V).

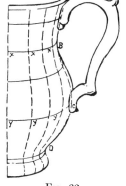

Fig. 33

In Fig. 34 is shown by a dotted tracing of this boundary how it actually differs from the profile curves in Fig. 33. In

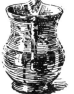

Fig. 34

sketching a profile curve, therefore, allowance must be made, as shown in Fig. 33. Note how x, x, x, the points of the smallest diameter, fall in an ellipse at that height; also the points y, y, y, of the greatest diameter. *One of these profile curves*, shaped according to its nearness to the boundary of the object, *should be sketched as a guide for the attachment of the handle.*

In the same way we observe *the shape of the handle itself to vary*

21

according to position, *from a profile view at the side* (A in Fig. 32) *to a view of its outer surface* (B in Fig. 32).

The Spout. — Looking directly into the jug from above (Fig. 35), we note that the spout is directly opposite the handle, so that a horizontal line through the middle of both would pass through the center of the circular top. We therefore mark the perspective middle of the top ellipse (O in Fig. 36) (that is, making the nearest half larger), draw a line through it from the center of the handle top, and mark the end of the spout on this line. For the width of the spout, set off perspective distances from this line either way on the top edge of the pitcher, remembering that the

Fig. 35

half nearest the end of the ellipse is much the more foreshortened; and that the difference is greater the more the top is foreshortened. From these points to the tip of the spout straight lines may be sketched as guides for drawing the edges, which

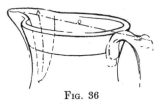

Fig. 36

may be straight but usually curve both upward and sidewise. The profile or center line for the spout is sketched like that for the handle (A in Fig. 36).

The Foot. — The drawing of the foot also needs some explanation, though covered by the cone principle of Chapter V. In profile it would appear as at A in Fig. 37, with the circles as straight lines; and the student should raise his model to the eye level and observe it thus. On lowering the model these seeming straight lines appear as ellipses (B, Fig. 37), and the lower part of the side boundary lines of both the pitcher and its foot move forward of the ends of these ellipses till tangential joinings are made at C and D. The upper part of the boundary of the foot moves back, joining the upper ellipse at E. In consequence, this side outline of the foot (E D) is a little lengthened, making its curve less round than in profile.

Fig. 37

The lower half of the jug, as we can now see, is a modified vertical cone with its apex down (A, Fig. 38). The foot is modified from two cones; one with the apex up, the other with the apex down (B, Fig. 38). See Chapters IV and V.

The Ornament. — The principle followed in suggesting the perspective of the ornament will be readily seen from the illustration (Fig. 39). The curved guide lines are parts of profiles similar to those for placing the handle and spout.

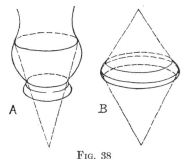

Fig. 38

Fig. 39

The student will now begin to understand that it is possible to recognize and suggest the solid rounding surface of the object by every line and touch upon it. To this end that part of the ornament nearest the eye is more emphasized in the final drawing. And looking carefully at the object, we see that besides its foreshortening, that part of the ornament near the boundary is less distinct, and is often lost in the reflections from its surroundings.

Chapter VII

A TIME STUDY

HAVING carefully studied the principles of cylindrical objects, it is now best to take a specified time, as fifteen minutes, for the more free drawing of such an object, choosing a simple one at first. Proceed as before, except that most of the measuring and testing must be omitted. This leaves

FIG. 40. A TIME STUDY.

time to draw slowly and thoughtfully, making the unaided eye do all that is possible. Study the general shape, looking long at the object, and moving the pencil several times, without marking over the paper where the lines are to be drawn to acquire confidence and certainty of touch. Require yourself to work with

no erasing (except of such construction lines as may show when the drawing is done), and to stop when the time is up. It will be found a valuable exercise to draw in this way the same object several times. After one drawing is done, carefully examine and test it to find the errors, but do not correct them on that drawing. Instead, make those points right in your next attempt at the same object.

Observe in Fig. 39 how the effect of glass is given by a few lines selected from those many graceful curves of delicate dark and light which appear in the object; also the sketching of its high lights, or window reflections, and the wavy distortion of lines seen through it. The straight lines give a firmness to the composition which is needed, since the bowl consists wholly of curved lines.

Chapter *VIII*

A GROUP OF CYLINDRICAL OBJECTS

FIG. 44 is an exercise in the grouping of cylindrical objects agreeably and appropriately together. The student is advised to first draw this example, using carefully the explanations given. After that, he should arrange and draw another group of two cylindrical objects.

Making the Composition. — In composing this second group, experiments should be made with a number of objects, combin-

FIG. 41

ing them in different ways. A Finder, which is a card having a small rectangular opening cut in it (Fig. 41), will greatly assist in judging the pictorial effect of a composition, especially in a rectangular margin. The student should look through it at his arrangement with one eye, letting its edge take the place of a margin, and moving it back and forth till the place is found where it makes the group look best. Little trial or "thumb-nail" sketches (Figs. 42 and 43) should also be made to determine the best arrangement.

FIG. 42 FIG. 43

In Fig. 44, for example, we observe that the objects are such as might naturally be placed together, and are placed in positions that are not unusual. Next their shapes make a pleasant relief or contrast to each other without harsh or awkward opposition; one being tall and slender and the other lower and round. Yet the teapot is not so low nor wide but that it echoes in some degree the dominant height of the candlestick, thus aiding harmony. Its spout is allowed to

project across the candlestick, thus contributing to the unity of the composition. The leaning bowl, by passing behind both, also strengthens unity, and by its lighter and more interrupted lines furnishes a transition, or connection, between the nearer objects and the white paper. These results might be secured by other groupings. But had the candlestick been in front, for instance, its projection above and below the teapot would have been so nearly equal as to seem uninteresting (Fig. 42). Yet we could have remedied this somewhat by placing the candlestick a greater distance in advance, or raising

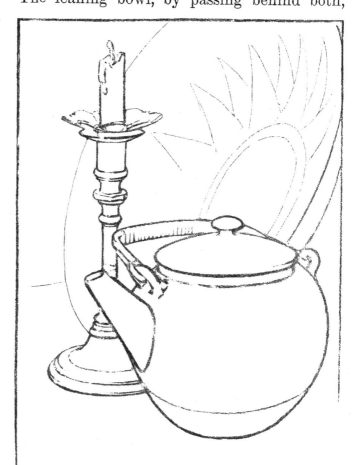

the teapot handle. Or the cover could have been placed on the ground in front (Fig. 43) — indeed, many possibilities will be suggested by a little study.

Drawing the Group. — In drawing this exercise, observe that though the bottom ellipses of the two objects are at the same level the nearer appears slightly rounder (Solutions of Problems, p. 162). Care must be taken in placing these ellipses to allow for the bulging of the teapot sides. Remember that in proportion as the bottoms are drawn foreshortened so must all spaces on the table be regarded as foreshortened. Note also that all ellipses in the candlestick which are nearer the eye level than the top of the teapot will be less round than those of the teapot.

The Teapot Ears. — In placing these, an ellipse may be used as a guide (A in Fig. 45). The middle points of the two ears should

A

B

PROFILE VIEW
SHOWING ARCH OF COVER

Fig. 45

be *on a line passing through the perspective* (that is, *actual*) *center* (o) *of this ellipse,* as were the handle and nose of the pitcher in Chapter VI. The cover is arched (B in Fig. 45), so that it conceals the back of its elliptical edge. This arched shape is distinctly seen in the form of its top boundary and is a very different shape from the ellipse. But this arched boundary does not fall in the actual middle of the cover (since we are looking down on it), but a little beyond that. The knob is in the actual middle.

The rendering of two things is more complicated and interesting than that of one alone. As the candlestick is farther away than the teapot, its lines are made lighter, and in places are quite lost. The lines of the glass rim, or *bobèche* are thinner, more interrupted and more smoothly sweeping. The leaning bowl may be omitted at this time, if found difficult. The principles of its construction are given later (Ch. XXVII). If omitted it will be found necessary to make the farther lines of the candlestick lighter yet, to serve in place of the bowl as a transition.

Chapter *IX*

CYLINDRICAL OBJECTS GROUPED
WITH FRUIT

A N example of grouping is here given in which part of the
group is cut by the margin, while the apples illustrate
the combination of natural forms with cylindrical ob-
jects. As in the preceding exercise, the student should compose

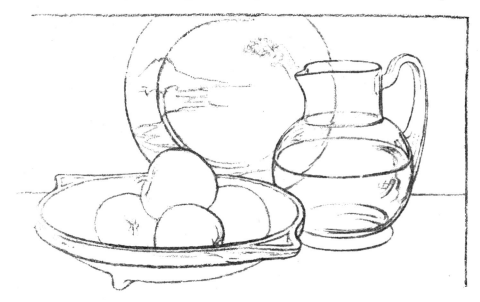

Fig. 46

a group corresponding to this exercise and draw it; and if inex-
perienced should draw this before making his original one.

Study of the Group. — In locating the pitcher on the paper, see
that its base is far enough from the dish for the two objects to clear

each other. Observe the generally elliptical shape of the curves in the glass pitcher; and how the edge of the plate is seen warped and interrupted through it. The plate is made subordinate, as

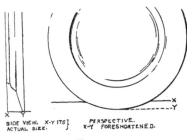

forming part of the background for the other two objects. Its position, appearing in its actual shape as a simple circle, contributes to the desired effect of quietness or subordination, as does its being cut by the margin line, and its lighter and slightly interrupted lines.

SIDE VIEW. X-Y ITS } PERSPECTIVE.
ACTUAL SIZE. X-Y FORESHORTENED.

FIG. 47

Since it is standing vertically, it must be supported by a vertical surface behind it. Consequently the table line (Ch. I) must be placed only far enough on the paper above the lowest point of the plate edge to express the foreshortened necessary distance of this point from the wall behind it (Fig. 47).

Chapter *X*

A GROUP OF OBJECTS FROM MEMORY OR INVENTION

THIS example illustrates the drawing of objects from invention or memory. The student may sketch this exercise as directed; then should invent or draw from memory one of his own arrangement, making small trial sketches as in Chapter VIII, and using the best of these in his

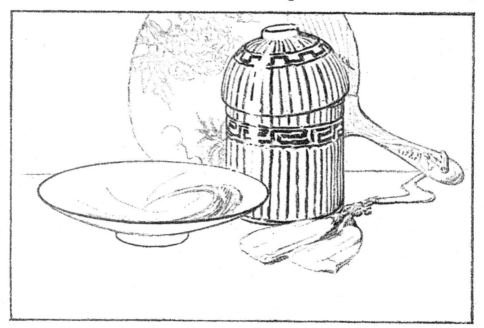

Fig. 48

final composition. Should his memory not be clear enough for this, it may be refreshed as often as necessary by study of the objects he chooses to draw, the only condition being that *the drawing be done without the object in view.*

Drawing the Above Study. — In this exercise the Japanese luncheon carrier is placed first. Its ellipses are sketched in full, whether entirely seen or not. The bowl-shaped top, being slightly inclined, is drawn on a leaning axis (A B in Fig. 49). But it is perfectly symmetrical on this axis (Ch. XXVII). This symmetry should be tested in the drawing by turning it to bring the axis vertical, when any error is easily detected. (Ch. XXVIII.)

The Flat Dish. — It was desired to draw the flat dish as it would appear if touching the luncheon carrier. Its height (x y) is therefore measured upon the front of that object from its lower

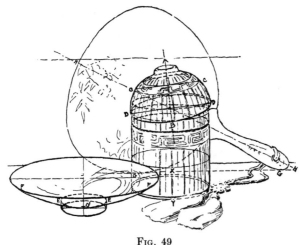

edge, and an ellipse of the proper roundness drawn at that height. The top ellipse of the dish would touch the other object somewhere in this ellipse, and so was drawn tangential to it. To obtain the bottom ellipse of the dish, this same height, increased to allow for its slightly greater near-

FIG. 49

ness to the eye, was measured downward from the dish top. But as the sides of the dish are flaring, this measuring was done from the estimated true middle (O in Fig. 49) of the top of the dish, giving O' for the true center of the lower ellipse. The foot is like a very short cylinder. The flaring sides of the dish are drawn tangentially from the rim (F, F) to the upper ellipse of the foot.

The Ornament. — In drawing the ornament on the luncheon carrier the explanation in Chapter VI is recalled. On the cover the band of fret decoration appears narrowed at its front, and widest at the ends. It is a modification of the cylinder top in

Chapter IV. Note the foreshortening in its details, and how the lines of the fret express the curving form of the cover. It will be seen that the stripes on the object and some lines of the fret follow the profile lines mentioned in Chapter VI.

The Fan. — Like the plate in Chapter IX, the fan is purposely placed so that it is not foreshortened. Therefore the two points (G, G) at which it rests on the table appear, as they actually are, in a horizontal line. It also appears in its true shape, symmetrical on an axis passing through its handle (H, H). It is more easily drawn entire first, erasing later the part not needed.

Chapter XI

THE CYLINDER CONE AND BALL GROUPED —A PROBLEM FOR ORIGINAL STUDY

GENERAL **Conditions for Perspective Problems.** — Problems are to the student both a test of his comprehension of the subject thus far, and an exercise by which the subject becomes firmly fixed in his mind. To this end the drawings must be made *without the models in sight*, though they should be studied, and if necessary even sketched in the required positions before drawing. If the student is at loss to recall their appearance while engaged in work they may be studied as often as needed; provided only that neither the models nor sketches of them are before the student as the drawing is made. It cannot be expected that any object should be drawn until opportunity has been given for its thorough study; but on the other hand it is not mastered until it can be correctly drawn from unaided knowledge and memory. The stated dimensions are important, giving training in the expression of proportion, though drawings need not be full size.

FIG. 50

Drawings should of course be made without assistance, and without referring to the explanations in the back of this book. When the student has under the required conditions made his drawing, he may then test his work by consulting the explanation.

Conditions of this Problem. — In this problem the cylinder and cone are to be 4″ in diameter by 8″ high, and the ball 4″ in

34

diameter. The group is to be drawn as if resting on a surface which is twice the cylinder height below the eye, and at least six times its height distant. The cylinder stands on one end and the cone on its base, touching the cylinder and a little in front of it at one side. The ball also touches the cylinder, and is a little more in front of it on the other side. The plan (Fig. 50) will make this clearer.

Chapter *XII*

THE STUDY OF STRAIGHT–LINE OBJECTS

A Book with Back Parallel with the Face

FOR this study provide a book, two long pencils, and three yards of fine twine, also paper for sketching. Choose a book of interesting appearance; a somewhat worn, leather-bound book is best. Place it well back on the table in front of you and below the eye with its back next to and parallel with the picture plane, and its ends equally distant from you (Fig. 51).

Fig. 51

The Book Below the Eye. —Two surfaces are visible, the back and one cover. Count the edges seen (seven), then decide how many of these are actually horizontal.[1]

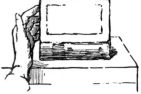

Fig. 52

If the book is placed as directed, its back, being parallel with the picture plane, will be seen in its true shape if traced upon it. Lifting the cover till it is vertical (Fig. 52), we see that the cover also now appears in its actual form. But as we drop it slowly

[1] It may not at first be realized that the ends of the cover are horizontal, as well as its sides. But as they are contained in a horizontal surface (in this case the cover), they also must be horizontal. Their perspective appearance must be distinguished from their actual position.

back till horizontal, we observe that the further edge seems to grow shorter because moving from the eye, and that the whole cover becomes foreshortened or narrowed from front to back,

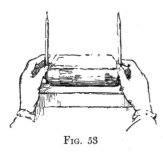

FIG. 53

like the circular ends of the cylinder in Chapter IV. If (as with the house in Ch. II), a pane of glass were standing in place of the imaginary picture plane, a tracing of the cover on that would be a true perspective of it. *How to draw on the paper such a perspective* is our problem. Stand the pencils against the nearest corners of the cover (Fig. 53); then closing one eye, and keeping the other exactly opposite the middle of the book, incline the pencils toward each other (being careful not to lean them back or forward) until they appear to lie just along the retreating ends of the cover (Fig. 54). Let another person hold a ruler against the pencils, moving it down until its edge seems to coincide with the further edge of the

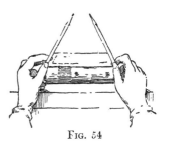

FIG. 54

cover (Fig. 55). Now the pencils and the ruler together picture *the apparent shape of the cover,* and we plainly see how *the apparent shortening of the back edge* (caused by its greater distance from us) *makes the ends appear to converge toward each other.* The question now is: Can the law of that conver-

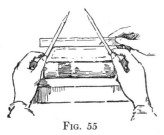

FIG. 55

gence be so determined that it may be applied in any drawing?

The Converging Book Ends. — Substitute for the pencils the string slipped under the cover to the back, and using one eye as before, bring the ends together so that the strings will appear to exactly coincide with the ends of the cover as did the pencils. (Be sure to keep the string vertically over the front edge of the book, not letting it fall back or forward.) The pencil may now

be taken in the other hand, and slipped down on the string, to form again the shape of the foreshortened cover (A in Fig. 59).

Still holding the string as before, raise the book and string a few inches, keeping the book level and the string taut (A in

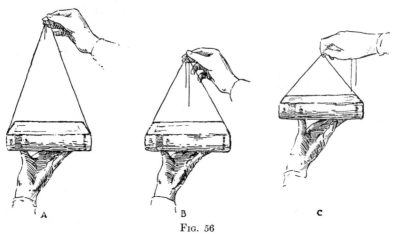

A B C

FIG. 56

Fig. 56). The string does not now cover the book ends, and the joining must be brought lower (as in B) that it may do so.

FIG. 57

If the book is raised more, the joining is yet nearer to the book, as in C; until when the book cover is at the level of the eye (Fig. 57) the string and the book cover both disappear in, or coincide with, the upper edge of the book.

Now, starting with the position last shown, (Fig. 57) hold the thumb and finger firmly at that place on the eye level (this can be done by noting a point behind it on the wall), and let the book drop slowly. Keep it exactly horizontal, and let the string slip through the stationary thumb and finger, so that their meeting point remains at the eye level. If this is carefully done, it will be seen that as the book descends, the string continues to cover the converging ends (as in C and B, Fig. 56). At the same time the cover appears to grow wider, and its ends more and more nearly vertical.

38

These experiments should also be tried with the lower cover, holding the book above the eye (Fig. 58), and raising and lowering it.

From the foregoing study it is easily perceived that, *provided we keep the book horizontal, the point toward which its ends appear to* 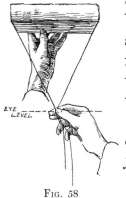 *converge remains always at the level of the eye.* We have therefore only to sketch the eye level at its right height compared with some measurement on the object and mark the point of convergence in the right place on it, to be able to use it for drawing these converging lines.

EYE LEVEL

We have also found that *the horizontal book covers* (like the cylinder top in Ch. IV) *appear foreshortened according as they approach the eye level,* whether above or below it (Figs. 56 and 58).

FIG. 58

Sketching the Book. — The book may now be replaced as at first. Then, holding the strings, as before, take the pencil as in B, Fig.

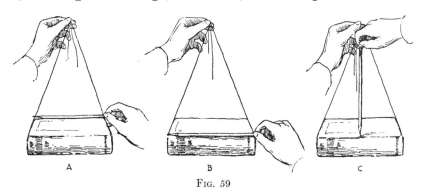

A B C

FIG. 59

59, that the thumb nail may be used as a sliding gauge. With it measure the length of the back of the book on its upper near edge and compare its length with the vertical distance from this edge to where the strings join (C in Fig. 59). (In this case it takes one and one fourth of the book length to reach the joining of the strings.) Now the back of the book may be sketched in, the point of convergence (the joining of the string) marked on

the paper one and a half book lengths above its middle, and lines drawn from the upper corners of the back to this point. On

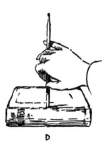

FIG. 60

these lines the ends of the cover are to be marked off. The perspective or apparent width of the cover may be found by measuring it with a pencil held vertically as in Fig. 60, and comparing this dimension with the length of the book. In this case the apparent width is one fourth of the book length.

The Level of the Eye. — This will be found of the greatest importance in all drawings. It should be carefully marked in the drawing as soon as the position of the objects on the paper give a basis for locating it. At first, another person may assist (Fig. 61), but a little practice will enable the student to find it for himself. The top of a pencil, held vertically over the objects, will appear as a straight line when at the height of the eye (Fig. 62). Or if any part of the study is as high as the eye, the eye level will be where any horizontal surface or any receding horizontal lines appear as straight lines. See Fig. 63.

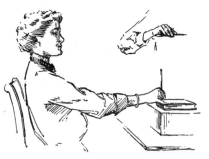

FIG. 61

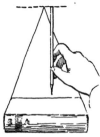

FIG. 62

Parallel Lines. — By holding one string down on the near end of a margin line on the book this line will be seen to converge to the same point with the two ends (Fig. 64). By placing a second book on and parallel to the first, we can show that *all lines parallel with the first two converging ones will appear to converge with them to the same point.* An important deduction from this is that *parallel lines appear to converge to the same point.*

It is also evident that since the whole book cover is foreshortened from front to back, the margins will be foreshortened

40

in the same direction. And we find that the side margins are foreshortened in length, but not in width; while the front and back margins are foreshortened in width, and the back one more than the front. This fol-lows the principle of the top of the hollow cylinder in Chapter IV.

FIG. 63

The Vanishing Point. — We see that the book ends seem to converge in proportion as the back edge of the cover appears shorter. If a second book like this were placed back of, and touching it, its front

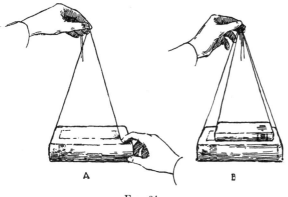

A B

FIG. 64

edge would appear of the same length as the back of this, and its back edge shorter, while its ends would converge in a line with those of the first book (Fig. 65). This can be imagined as repeated infinitely, each book appearing smaller than the one before it, and the cover ends all falling in the same converging lines, until a point would be all that could

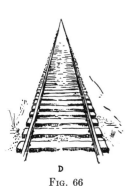

D

FIG. 66

represent the last book. The row of books might be said *to vanish in this point*, which is therefore called *the Vanishing Point of such lines as converge toward it*, as do the ends of the book cover. Vanishing Points, like the Level of the Eye, play a most important part in the study

C

FIG. 65

of perspective.

A familiar example of vanishing lines, as those which appear to vanish, or converge perspectively, are called, is found in a

receding railroad track (Fig. 66). The ties appear shorter as they are successively farther from the eye; and the rails appear and converge, till the whole track, if it could be seen for a long enough distance, might seem to disappear, or vanish in a point.

Chapter *XIII*

DRAWING THE BOOK IN TWO POSITIONS

T HE student may copy this example, but in any case should place a book successively in these positions and draw from that; having it high enough or far enough from the eye, to see it in a normal position as explained on page 2. He should also make drawings from memory of a book in both positions, expressing them as artistically as possible.

In the first position on this sheet, the eye level falls off the paper; and may be marked for use on a piece of paper fastened to the drawing (Fig. 68). See that the table line is high enough on the paper to clear the lower back corners of the book.

It will be observed that the back of the book is not quite flat but slightly curved — a modification of the cylinder. This will be understood by holding the cylinder horizontally (Fig. 69).

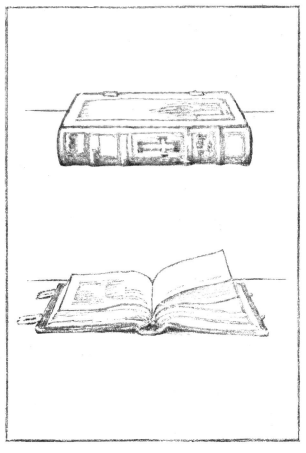

FIG. 67

The curve opposite the eye is seen as a straight line, since it coincides with (or lies in a plane passing through) the direction

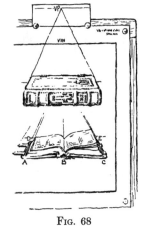

of seeing. The farther these lines are from coinciding with this direction (in this case to right and left) the more apparent is their curvature.

For the second position in this exercise the book is opened and turned around so that its ends are parallel with the picture plane. They may therefore be drawn in their true shape like the back of the book. The sides and all lines parallel with them now vanish to VP[1] (on the eye level directly in front of the student). Note that points A, B, and C,

FIG. 68

where the book rests on the horizontal table (Fig. 68), are in a straight line that is parallel to the picture plane, and therefore drawn in its true direction, which is horizontal. Observe the projection of the covers beyond the leaves, and that it extends backward at D and E. The thickness of the covers

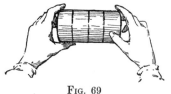

FIG. 69

must be recognized, though the wearing off of the edges and corners may obliterate their sharpness. Since the right and left corners of the book are equally distant from the eye care must be taken that the covers are drawn of equal width. The clasps must be long enough to allow of their being fastened when the book is closed. Their ends are in a line converging to VP.

The table line, being a subordinate element, should be so placed that most of its length is covered. Avoid anything which would tend to emphasize it, as making it coincide with the back corners of the book.

[1] Used as an abbreviation for the vanishing point.

Chapter *XIV*

THE BOOK WITH A CYLINDRICAL OBJECT

THIS exercise (Fig. 70) combines a book in one of the two positions previously studied with a cylindrical object. The student may draw this example or not, according to his proficiency; but should compose and sketch a similar group, arranging and making trial sketches of several

FIG. 70

compositions. Observe that the extreme points of the book must be equidistant from the eye, as in Chapters XII and XIII. But as soon as we place another object with the book, the two must be considered *together* as forming one group or picture.

FREEHAND PERSPECTIVE

This brings us to reflect that whatever the number of objects we include in our picture, it is always drawn *with the eye directly opposite the picture as a whole,* so that the center of seeing is *in the middle of the group from side to side.* We also recall that the picture plane is *always at right angles* (viewed from above) *to the direction of seeing.* So, if the cylindrical object is placed on, or in front of the book (as in Figs. 70 and 71), the central direction of seeing the picture is not changed; and the picture plane continues parallel to one set of lines in the book as in the preceding exercise with the book alone. (See plan, Fig. 71.) If, on the other hand, the cylindrical object is placed at the side and the picture thus enlarged *in one direction only* (Fig. 72), the direction of seeing is immediately thereby moved to correspond, and the picture plane moves with it. The book will cease to be equidistant at its ends from the picture plane and cannot be drawn as previously studied. This subject is considered more fully in Chapters XXXIV and XLI.

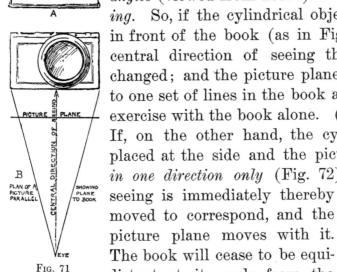

It would of course be possible to add objects to the book equally at both sides (as in Fig. 73), but danger of stiffness in such an arrangement must then be remedied by some such device as the string of beads, making a more complicated study than is desirable at present.

For this exercise, therefore, place the cylindrical object somewhere within the extreme points from side to side of the book.

It will be observed that a cylindrical object is always placed so

that a part of its base is seen, if only a very small part. For this reason, it is not put behind the book unless the foot can be left partly visible. The reason for this precaution is the uncertain effect produced by a study in which it is not observed.

Chapter XV

THE CYLINDER AND RECTANGULAR BLOCK — A PROBLEM FOR ORIGINAL STUDY

FOR general directions see Chapter XI.

The Models. — The rectangular block is 4″ square by 8″ long. It may be made of cardboard, cut as in the diagram (Fig. 74), and glued,[1] like the cube in Chapter XVI. Or two cubes, made as there directed, may be used in its place. The cylinder is 4″ by 8″, and has a circle about its middle.

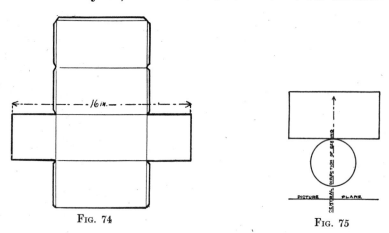

FIG. 74 FIG. 75

Positions. — The block lies on one long face, its long edges parallel with the picture plane. The cylinder stands on one base in front of the block, touching it at its middle (Fig. 75). The models rest on a surface three times the height of the block below the eye, and are four feet distant.

[1] The light lines indicate where it is scored and bent for the edges of the block. The quarter-inch projections are laps for fastening.

Chapter *XVI*

THE FURTHER STUDY OF STRAIGHT-LINE OBJECTS—A CUBE AT ANGLES WITH THE PICTURE PLANE

T**HE Model**. — For this study make a cube, four inches on a side, from cardboard cut as in the illustration (A, Fig. 76). Pass a string under one edge and out of adjacent corners (B, Fig. 76) before glueing together.

Study of the Subject. — Turn the cube so the string comes from the upper front corners, and place it as the book was placed in Chapter XII (Fig. 77). Now, holding a front corner of the cube firmly, revolve the cube on that corner, bringing the side x into sight (Fig. 78). The moment the cube begins to revolve, the front, y, begins to be turned away, ceasing to be parallel with the picture plane, and tending toward coinciding

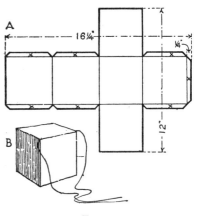

FIG. 76

with the direction of seeing. In proportion as it is turned away, its right edge (H) becomes shorter, so that its upper and lower edges (E and F) appear to converge. The cube may be revolved until these edges (and their parallel, D) in their turn converge directly in front (Fig. 79), as A and B did

FIG. 77

at first. Then the side x, becoming parallel with the picture plane, will in turn be seen in its true shape, while its top and bottom edges appear horizontal.

Now turn the cube slowly back to the position of Fig. 78, and with the strings find the converging point of A and B.

FIG. 78

Figure 80 shows the cube in this position, and the vanishing of A, B, and C by the use of three strings. The lines at right angles to them, which in Fig. 79 vanished directly in front, here (in Fig. 80) vanish so far to the right that the strings cannot reach their vanishing point.

If the cube is now revolved in the opposite direction, this vanishing point (which we may call VP2[1]) again moves inward, as seen in Fig. 81.

It will be now readily seen that though any set of parallel horizontal lines (as A, B, and C) are directed more to the right or left, according as the cube is turned,

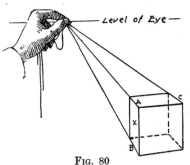

FIG. 80

they are never actually raised or lowered. Hence their vanishing point does not move up or down, but is always found on the eye level. We may therefore conclude that *receding horizontal lines always vanish in the eye level.*

FIG. 79

We also confirm what was observed in Chapter XII, that *parallel lines vanish to the same point.*

Let us now study *the effect on the shape of its faces* of revolving the cube. In Figure 77 the front face, *y*, appears in its true shape, while lines at right angles to this face (as A and B) vanish directly in front, and the sides *x* and *y* are invisible. As the cube is revolved

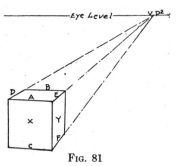

FIG. 81

(Fig. 78) so that *x* comes into sight, so *y* is turned away, or

foreshortened. As *x* widens, and its horizontal edges (A and B) seem less steep, the other side narrows, and its horizontal edges (E and F) appear more steep. *Steepness of the horizontal edges, therefore, goes with foreshortened surfaces.* Good judgment on this point is very important, as the cube is the basis for later estimates of foreshortened surfaces. For this reason much space has been given to its study. It should be drawn with great care till thoroughly mastered.

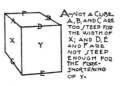
A.—NOT A CUBE. A, B, AND C ARE TOO STEEP FOR THE WIDTH OF X; AND D, E AND F ARE NOT STEEP ENOUGH FOR THE FORE-SHORTENING OF Y.

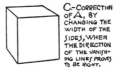
C.—CORRECTION OF A, BY CHANGING THE WIDTH OF THE SIDES, WHEN THE DIRECTION OF THE VANISHING LINES PROVES TO BE RIGHT.

B.— CORRECTION OF A, BY CHANGING THE SLANT OF THE VANISHING EDGES, WHEN THE WIDTH OF THE SIDES IS FOUND TO BE RIGHT.

FIG. 82

The Recession of Horizontal Surfaces Toward the Eye Level. — It will be interesting here to place several cubes in a receding row, and see how the vanishing lines, being all included in one or the other of two sets, will vanish accordingly to one or the other

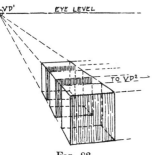

FIG. 83

of two vanishing points. Taking out every second cube (Fig. 83), we find the vanishing of those left to be unaltered. We also perceive that the table on which all rest seems to rise as it recedes, apparently tending to vanish or merge itself in the line marking the eye level.

Looking at the tops of the cubes, all situated in one horizontal plane, and recalling the horizontal surfaces in previous drawings (as the book covers and the cylinder ends) we conclude that *all horizontal surfaces appear to approach the level of the eye as they recede.* This is seen to be true whether they are below the eye or above it. The vertical distance between receding horizontal planes must appear less as it is farther from the eye, till at an infinite distance it would be entirely lost, and the parallel planes would vanish in a line (the eye level) as parallel lines vanish in a point.

The Eye Level. — The eye level, or level of the eye, is not *actually* a line; but a height, or invisible horizontal plane, which may be said to extend indefinitely. Thus if the student's eye is five feet above the ground, his eye level passes through and includes every point at that height. But as each one's eye level is " edge to " him, it would (if visible) always appear *to him* as a line, hence it is always drawn as a line.

Chapter *XVII*

THE CUBE IN TWO DIFFERENT POSITIONS

THIS exercise should first be drawn from the objects, and then from memory, according to the general directions for memory work (Ch. XI). Two drawings on one sheet, showing the cube in different positions, are to be made. They should be represented as of the same size, which may be

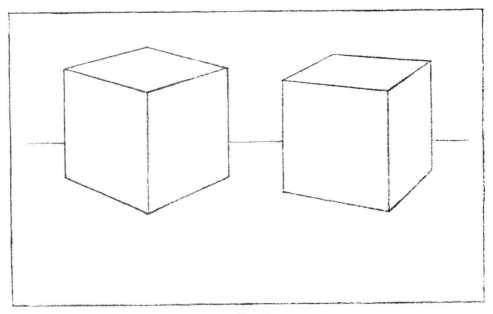

FIG. 84

done by making their nearest vertical edges of the same length and at the same height on the paper, and using the same eye level for both.

Position of Models. — For the first drawing, place the cardboard cube so that its front faces are equally turned away, or make angles of forty-five degrees with the picture plane (A in

Fig. 85, also plan). Notice that its upper back corner will then appear exactly behind the upper front one, the vertical sides

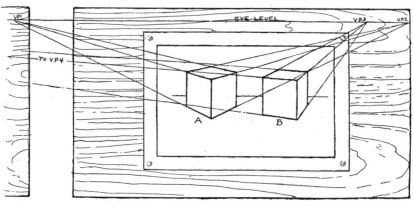

FIG. 85

of equal width and the side corners opposite each other and equidistant from the center. In the second position the cube is turned so its right face makes an angle of sixty degrees with the picture plane (B in Figs. 85 and 86).

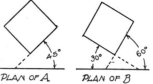

PLAN OF A PLAN OF B

FIG. 86

Making the Drawing. — Fasten the paper in its place on the desk or have its position so marked that it can be accurately returned to the same place. Draw the margin lines and lightly mark the extreme points for the two cubes (Ch. IV). Note that

DIAGRAM SHOWING A CONVENIENT ORDER FOR DRAWING THE LINES OF THE CUBE, AND OF RECTANGULAR OBJECTS IN GENERAL.

FIG. 87

in the first position (A, Fig. 85) the cube occupies slightly more space, both horizontally and vertically. Since the cube is a type solid the lines in its final rendering are simple and firm, only varying slightly in thickness to suggest distance. Begin the first cube with the easiest part, which is its nearest vertical edge. This is parallel with the picture plane, and so is drawn in its true position. As soon as this line is placed mark the eye level (in this case it falls off the paper) finding its height as directed for the book. The numbers on the diagram (Fig. 87)

give the order in which not only cubes, but rectangular objects generally, should be drawn. Get the direction of lines 2, 2 by pencil measurement (Ch. II) with especial care, as their meeting with the eye level determines the vanishing points. Hold the pencil vertically in front of, or even touching the nearest end of line 2 (Fig. 88). Then keeping

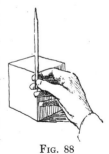

FIG. 88

FIG. 89

it parallel with the picture plane (that is, *not* receding as the line does, but resting in an imaginary vertical plane) revolve it downward to the right until it seems to cover line 2 (Fig. 89). Holding it thus, with the other hand slip the paper (on which the drawing has been started) up vertically behind it till the pencil touches the upper end of the vertical line already drawn, and lies on the paper, showing

FIG. 90

the direction line 2 should take (Fig. 90). (This puts the paper in the position of the picture plane.) Draw this first line 2, and mark its vanishing point on the eye level (VP1). The direction of the other line 2 could be found in the same way but as in this case they make equal angles with the picture plane, their vanishing points will be equidistant from the center, and VP2 can therefore be so located, and the second line 2 drawn to it. Lines 3, 3 are then drawn (recalling that *parallel lines converge to the same vanishing point*).

A

B

FIG. 91

For lines 4, 4 compare the apparent width of a near vertical face (A in Fig. 91) with the front vertical line (B in Fig. 91).

(This front line, being seen in its actual position and unforeshortened, is the best for use as a unit of measurement.) Mark to right and left from line 1 in the drawing the proportionate distance so found (in this case two thirds of line 1) and draw lines

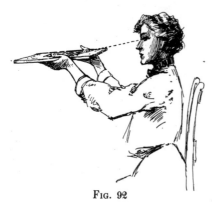

4, 4. From their upper extremities draw lines 5, 5 to their respective vanishing points.

For the second drawing place the cube as directed, and proceed as with the first cube. In this case VP2 falls so far away that it cannot be shown in the illustration (B, Fig. 85). But we know that it must fall somewhere in the eye level. (It will be so found in the illustration, if tested.) At this stage a string pinned to VP4 will aid in detecting errors of vanishing, and will also make real the fact that these lines must vanish *precisely to their own vanishing point.*

A Valuable Testing Method. — After this the following far more speedy and convenient method of testing should be acquired: With one eye closed hold the drawing close to the eye level, and turn it so that one set of vanishing lines are directed to the open eye (Fig. 92). Push the drawing back or forward as needed till the

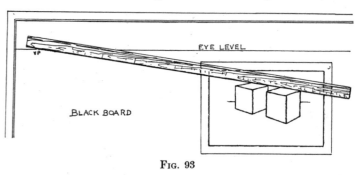

FIG. 93

eye occupies the place of the vanishing point for the lines in question. Now sight back over this set of converging lines, when it will be found that any failing to properly vanish are quickly seen and easily noted for correction. A little expe-

rience is needed to do this successfully, but it is well worth the trouble.

Testing Before a Class. — An impressive method of demonstrating the vanishing of lines when teaching a class is the following. Draw a long horizontal line on the blackboard and mark it "Eye Level." Tack each pupil's drawing in turn on the blackboard so that the blackboard eye level coincides with the eye level of the pupil's drawing. With a long ruler follow out one of the vanishing lines (Fig. 93), and find its vanishing point on the blackboard eye level. Holding the ruler at this vanishing point as a pivot, swing it over the other lines of the set that should vanish to that point. The test is convincing, even to children; and helps greatly to form a standard of accuracy.

It should always be remembered, however, that such measuring is *only for testing*, never for *drawing* the lines.

Chapter *XVIII*

A BOOK AT ANGLES TO THE PICTURE PLANE

THE student may copy this example but must in any case draw from a book similarly placed; and finally make a correct and spirited drawing of the same from memory.

The position of this book is like that of the last cube (Ch. XVII). In studying this position begin with the book directly in

FIG. 94

front as in Chapter XII. Note the convergence of its ends; then turning it slowly into the required position for drawing (Figs. 94 and 95), observe how the ends change in their convergence and how their vanishing point moves to the right on the eye level as the book is turned. Look also at the long edges of the book and see how, at the first movement of revolving it, they

cease to appear horizontal, and vanish toward a point which, though at first infinitely distant, must nevertheless fall on the eye level.

Drawing the Book. — Sketch the margin lines, and plan a good position of the book in relation to the inclosed space. Mark the height of the eye level as soon as a dimension (as xy, Fig. 95) by

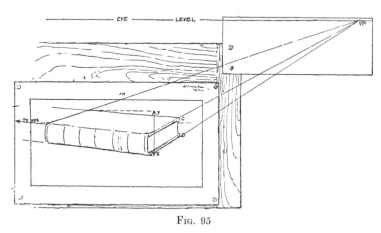

<div align="center">Fig. 95</div>

which it can be estimated is decided on. Find the direction of the book edges (corresponding to lines 2, 2 in the cube in Ch. XVI) with especial care. Sketch in the book with delicate lines, proceeding in the order observed when drawing the cube, and correcting where necessary.

Artistic Expression. — Finally, the subject should be rendered artistically. To accomplish this, the line is adapted to the quality of that portion on which it is used. Certain features may be selected for use to augment interest; as the curving ridges, the ornament, and the title space on the back, or even the worn corners. But having expressed in these details the point intended (as a worn corner by the shape of its boundary line) take care to do no more. It is wearisome, for instance, to see lines on these corners to represent the separation into layers caused by wear. Lines also produce a dark color, while worn corners are generally light; and are also undesirable places for the use of dark spots.

<div align="center">59</div>

FREEHAND PERSPECTIVE

As the vertical edges of the cube are drawn vertical because parallel with the picture plane, so the corners of the book must be made vertical in the drawing, as they are in reality. For instance, points C and D being in a vertical line, must be so placed in the drawing. The same is true of the curves on the back of the book.

At this point the student readily sees that *all vertical lines* (since the picture plane is vertical) *will be parallel to the picture plane, and must invariably be drawn as they actually are, or vertical.*

Chapter *XIX*

TWO BOOKS AT DIFFERENT ANGLES TO THE PICTURE PLANE

BEGIN the study of this subject by placing the books as in Fig. 97. Observe that in this position there is but one vanishing point for the two objects, the ends of

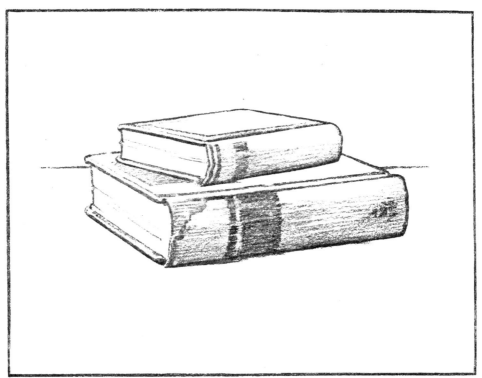

FIG. 96

the books being all parallel, and their other horizontal edges parallel with the picture plane. Now turn the whole group, as in Fig. 98, and see that we have two vanishing points,

one for the ends and the other for the long edges of the books.

Now revolve the upper book a little more (Fig. 99), so that its horizontal edges cease to be parallel to those of the other, and it will have its own points of convergence (VP3 and VP4). Its length appears lessened, and its ends longer, for this

Fig. 97

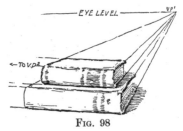

Fig. 98

change. The shortened edges vanish more steeply, and those which have become longer appear less steep. We find, as would be expected, that *when lines cease to be parallel, their vanishing points are different.*

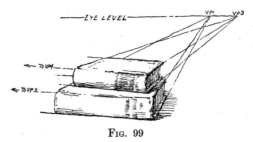

Fig. 99

Chapter *XX*

THE ACTUAL CENTER OF THE CIRCLE AND MEASUREMENT INTO THE PICTURE BY PARALLEL LINES

PRELIMINARY Study. — Does the eye see half way round the cylinder? The question is best answered by experiment. Holding the cylinder vertically and rather near (to more easily see the facts), mark on it the points where the side boundaries appear to meet the top (A and B in Fig. 101). It will

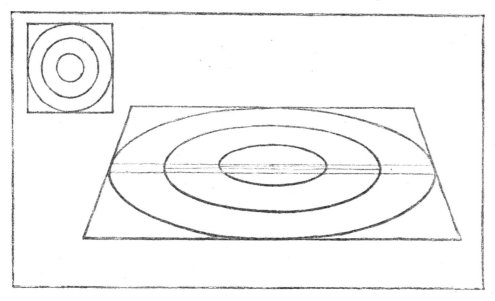

Fig. 100

be found that they are actually less than half way from the front to the back (Fig. 102). Yet the pencil has marked what the eye *saw* as the greatest dimension. As shown in Fig. 103 this apparent greatest dimension (A B) forms the long diameter of the ellipse

in the perspective view. It is evident, therefore, that *the eye does not see half way round the cylinder*, and (as seen in Ch. IV) that

the long diameter of the ellipse is not an *actual* diameter of the circle, while that portion of the circumference beyond the long diameter (A B) is actually more than half of the circle, the part in front of A B appearing equal to it only because nearer to the eye.

The actual position of the apparent greatest dimension (the long diameter) *changes with the position of the observer.*

The plan (Fig. 102) shows that C D would appear as the greatest dimension if the eye should be at 2. This also may be seen by experiment (as in Fig. 101).

Planning the Exercise. — In placing this exercise observe that the perspective of the concentric square and circles is made much larger than the geometric diagram, to show more clearly the perspective details.

Drawing the Circles. — When the square has been drawn in perspective (like the top of the cube in Fig. 77) its actual center (*o* in Fig. 103) is found at the crossing of its diagonals, as in the geometric diagram above. In the diagram the ends of its diameters mark the points (C, D, E, and F) where the circle touches the square, and they will do the same in

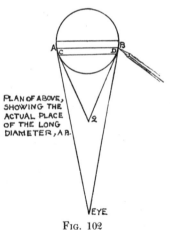

PLAN OF ABOVE, SHOWING THE ACTUAL PLACE OF THE LONG DIAMETER, A B.

FIG. 102

the perspective. The diameters pass through the true center and one is parallel to the picture plane. It can therefore be drawn in the perspective in its actual direction, giving two points (*c* and *d*). The other diameter, being parallel with the receding sides of the square, vanishes with them in the eye level directly in front (at VP1) giving points *e* and *f*. Now, though the actual

diameter of the circle touches the square in *c* and *d*, the ellipse *appears* longest at a part nearer than *c* and *d*, which seems to be exactly half way between *e* and *f*. Through this half-way point (*x*) the long diameter can be drawn; making it longer than *c–d*, and yet not quite touching the square. The ellipse is then easily sketched through these six points (*a*, *b*, *c*, *d*, *e*, and *f*), making it symmetrical on *a–b* and *e–f*.

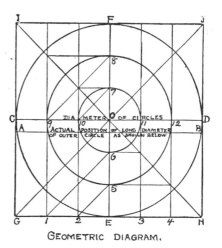

For the other ellipses the points where they cross the actual diameter of the circle (*c–d*) are marked by lines from 1, 2, 3, and 4 which vanish in VP1, giving four points (9, 10, 11 and 12), two for each of the smaller ellipses.

GEOMETRIC DIAGRAM.

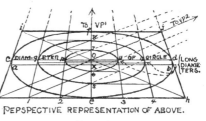

Measuring Distances into the Picture. — For the front and back points of these ellipses, line *e f* must be divided into six *perspectively* equal parts, as EF in the diagram is divided into six *actually* equal parts. This can be done, and in practice usually is

PERSPECTIVE REPRESENTATION OF ABOVE.

FIG. 103

done, by the eye (as for the cylinder in Ch. IV), noting that the true center (*o*), already known, is one point of division. But the use of the diagonal for such distances is simple and often a convenience. Thus it is easy to see that in the diagram the vertical lines from 1, 2, 3, and 4 cut the diagonals proportionately to the divisions on GH[1] in this case into six equal parts. These divisions can in turn be transferred to EF by horizontal lines from the points on the diagonal HI, giving 5, 6, 7, and 8, the four

[1] Students of geometry will recognize in this the problem of dividing a line proportionately by means of parallel lines crossing a triangle.

FIG. 104

points needed. In the perspective the method is the same, using lines *perspectively* parallel to *e–f* — that is, the lines already drawn from 1, 2, 3, and 4 to VP1. This use of the diagonal occurs further on, as for the steps in Chapter XXII.

A Second Method. — The vanishing point of the diagonal can also be used to obtain these points. Thus the diagram shows that lines from 1, 2, 9, and 10 parallel with the diagonal GJ will mark on EF the same divisions. In the perspective these lines will appear perspectively parallel to the diagonal — that is, drawn to the same vanishing point. Since they are horizontal, that vanishing point will be on the eye level. Therefore the diagonal GJ can be carried out to the eye level to find its vanishing point (VP2) to which the parallel lines are drawn.

The principle to be remembered for use is: *Whatever measurements can be obtained geometrically by the use of actually parallel lines, can be obtained in perspective by the use of perspectively parallel lines.*

It must, however, be noted that these are only *relative* measurements. A first distance into the picture — the foreshortened width of the square in this case — is determined freehand by past experience (as with the cube). Mechanical perspective gives methods of obtaining this first distance, the position of the eye and the picture plane being given. It can also be obtained from a side view, by using the same data. Both these methods are too complicated for common use in freehand work. Such proportions are so easily estimated by recalling the cube that it is better to rely on a trained judgment for them.

Chapter XXI

BOOKS WITH A CYLINDRICAL OBJECT

T HE student should take this exercise as previous ones, copying first if he needs to do so, then composing and sketching a similar study, and finally making a drawing

FIG. 105

from memory. For both of the latter several different arrangements of objects, with trial sketches, should be made; and the best chosen to use in the final drawing.

The Finder (Ch. VIII) should be used to compare the effect of different compositions, also the effect of cutting out

compositions from larger ones by different margins. Note that in Fig. 106, with a tall object, the books are turned so that their horizontal dimensions are not great enough to neutralize the dominant vertical effect. In Fig. 107, on the other hand, the long horizontal dimensions of the books and the low flat dish harmonize very well, and this arrangement

FIG. 106

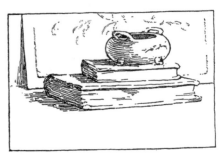

FIG. 107

necessitates a marginal rectangle longer from side to side. The books and dish alone make a good simple arrangement, but the tray may be added if desired.

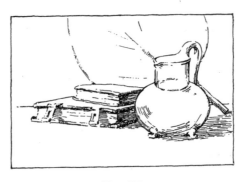

FIG. 108

Chapter *XXII*

THE STUDY AND DRAWING OF A HOUSE

MODEL for the Study. — Make an equilateral triangular prism from cardboard cut as in the diagram (Fig. 110), and place it on the top of two cubes. Put a box or

FIG. 109

books on the table under this model, raising it so that the level of the eye will fall one-fourth way up on the cubes (Fig. 111). Place the model about sixteen inches from the eye, and turn it so its long edges will make angles of thirty degrees with the picture plane (Fig. 119). It may now be regarded as the type form of a house, seen (in proportion to its size) from an ordinary posi-

tion for viewing a house. By aid of the imagination, it may be regarded as a house of two stories, with a front door in the middle of a side, the box top taking the place of the ground.

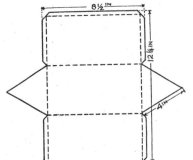

FIG. 110

This exercise should be first drawn in thin, light lines, studying the diagrams, and following the directions. The construction lines should then be erased, and the drawing rendered as shown in Fig. 109.

Drawing the Exercise. — Begin with the nearest vertical edge of the house. The model was placed so that the level of the eye should be one-fourth way up the height of its rectangular part because the eyes of a person standing might be about five feet above the ground, and the height of a two-story house at its eaves about twenty feet. Mark the eye level on the paper therefore, one fourth of the height of the nearest edge from its bottom, and take the direction of lines A and B (Fig. 112)

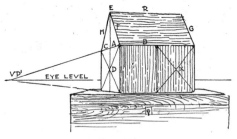

FIG. 111

to determine the two vanishing points, exactly as was done with lines 2, 2 in the cube (Ch. XVII) although, being above the eye, they appear to tend downward. Draw the two lower horizontal lines and the side vertical lines as those of the cube were drawn.

To construct the roof recall that the end of our model is an equilateral triangle (Fig. 113) with its apex over the center of the house end. Draw the diagonals of this square house end and carry up a vertical line of indefinite length from its center, on which the apex of the gable is to be marked. The actual roof height of our small model may be found by this diagram;

but as that makes a roof steeper than is usual, we will set it off less in the drawing, that is, making EC (Fig. 112) but a

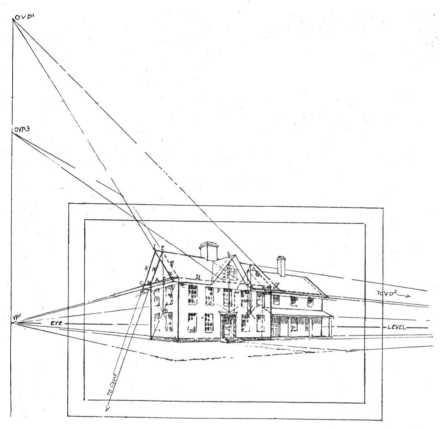

Fig. 112

little more than CD. (Since these distances are in the same vertical line, and so at the same distance from the picture plane they are seen and drawn in their true proportions to each other.)

The sloping sides of the gable may then be drawn to the house corners, and the ridgepole to VP2. The gable apex on the other end may be found by drawing a vertical line from the center (x) of the invisible end to cut the ridgepole. Its slanting sides are drawn to complete the blocking-in lines thus far of the house.

END VIEW

Fig. 113

Oblique Vanishing Lines. — We have said little about the slop-ing end lines of the roof. But now, looking again at our model (Fig. 111), we see that the ridgepole, R, because it is farther away than the eaves, appears shorter, so that the slanting ends (F and G) of the front surface of the roof appear to converge upward. Turning to the drawing, we find in con-firmation of this that (if the drawing has been carefully made) these lines do thus converge. Now let us search for the general truth governing that convergence. These slanting ends are not horizontal, so that we should not expect them to tend toward the eye level; and we observe that they do not. But they are actu-ally parallel to each other and therefore must vanish or appear to converge to the same point. *How to find that point* is the question.

Put some books in the place of the house model, and arrange them so that their edges vanish like the house edges. Now raise

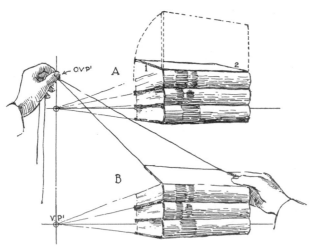

FIG. 114

the upper cover (A, Fig. 114), and observe that its ends 1 and 2, though still parallel with each other like the ends of the roof, have ceased to be parallel with the other book ends. They therefore no longer vanish toward VP1, but to a higher point. We have not, however, turned these edges to right or left, but have simply lifted their farther ends or revolved them in parallel vertical planes. Therefore *their vanishing point cannot move to right or left;* but as they are revolved, *must appear to move directly upward, or in a vertical line passing through VP1.* This continues until the cover becomes

vertical; when its ends appear in their true position and cease to vanish, like all vertical lines.

Place strings under the cover, as in Chapter XII. Holding the strings with the left hand as in the illustration (B in Fig. 114) raise the cover with the right (keeping the strings parallel to the picture plane). By this experiment their convergence toward a point in the vertical line from VP1 is more plainly shown. Since these slanting book ends are neither horizontal nor vertical but oblique to both directions, their vanishing point or that of any set of oblique lines, may be distinguished as an Oblique Vanishing Point, or OVP.

By revolving the upper cover farther, or opening the lower cover and using the string (A in Fig. 115), oblique vanishing points below the eye level may be determined. And the apparent direction of oblique lines can be found with the pencil exactly as that of any line (B in Fig. 115).

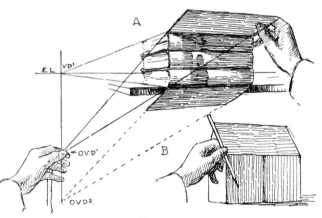

Fig. 115

Vanishing Traces. — By turning one of these illustrations around, to bring the eye level vertical, as in Fig. 116, it will be seen that the line containing OVP1 and OVP2 serves a purpose similar to that of the eye level. We note that *the surface formed by the visible ends of the books appears to recede, or vanishes, toward this line.* If a larger book be placed against the other ends, the surface of the larger book, being parallel to the visible ends of the other books, will be found to vanish toward the same line. It may be concluded that *all surfaces parallel to the book ends in this case will vanish in this line,*

exactly as all horizontal surfaces appear to vanish toward the eye level. We may call this line a Vanishing Trace. The eye level is such a vanishing trace for all horizontal surfaces. See note, Chapter XI, in Solutions of Problems.

First replacing the house model as in Fig. 111, we now turn to the drawing and test these oblique lines (F and G in Fig. 112). If correctly drawn they will be found to converge toward a point (OVP1) directly above VP1. At once use is made of this point for drawing the ends of the roof projection (suggested in the model by pinning cardboard as in Fig. 117). These edges are parallel with the corresponding roof edges, like the book margins; so their width can be set off on the upper line of the house (B, Figs. 112 and 117) to right and left, (points x and y) remembering that the nearer distance appears a little greater. Through these points draw lines vanishing to OVP1. A similar projection is measured downward on a continuation of the oblique gable edge F beyond its lower end (z); and through

Fig. 116

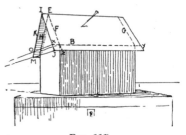

Fig. 117

this point a line parallel to B (that is, vanishing with it in VP2) forms the eaves. (The estimation of these last measurements by the eye forms an important part of the student's training and should be carefully thought out. Thus the eaves projection from line B forward is more foreshortened than the gable projection from F to the left; and distances should be set off accordingly.)

The lower oblique vanishing point (OVP2) is used for the projections on the back slope of the roof. Continue the back oblique roof edge (line H) to meet the vanishing trace through VP1, giving OVP2. Draw line K from the near end (I) of the ridgepole to OVP2, and cut it by a line from the nearest eaves corner to VP1. Where this line cuts the oblique edge K will be the eaves corner (M) for the far side of the roof; and a line from it to VP2 forms the eaves on that side.

There is another way of getting the projections on the further slope of the roof, which is useful in case OVP2 falls too far away to be conveniently used. Turning the model we see that the invisible line (L in back view, Fig. 118), if carried to the edge, ends in O, horizontally opposite x (end view). A line from x through O would therefore vanish in VP1.

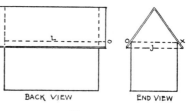

BACK VIEW END VIEW

FIG. 118

Hence, to obtain O, line L is carried forward indefinitely, and cut by a line from x to VP1. The desired edge is then drawn from point I through O indefinitely, and cut by a line from J to VP1, giving the corner, M.

The "L" Part of the House. — The plan (Fig. 119) shows its position. Its width is marked off on the farther (invisible) end of the house, and it is drawn as was the main part of the house. Note the less steep slope of the porch roof (Fig. 112), so that its oblique lines are not parallel with those of the other roofs but have another vanishing point, OVP3, lower in the same vertical line.

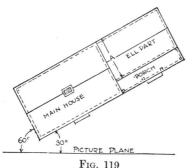

FIG. 119

Windows and Doors. — The windows and doors may be marked on the model (Fig. 120). It will be easily seen that their top and bottom edges are all parallel to the horizontal lines of the

side on which they are located and therefore vanish to the same point. Mark their heights on the nearest vertical edge of the house, and draw lines (as P, in Fig. 112), thence to the vanishing

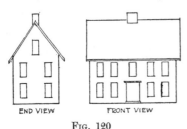

END VIEW FRONT VIEW

FIG. 120

points. On these lines their perspective widths are to be set off. Begin with the door. Find the middle of the house front by its diagonals, and make the near half of the door a little wider than the far one. Check this by seeing that the remaining distances (from the door to the front corners of the house) are also *perspectively* equal, that is, the near one larger. Mark the sides of the windows in the same way. Remember that since the space between the near window and the near corner is considerably nearer to us than that between the far window and the far corner, more difference should be made in their size than between the halves of the door.

The width of the windows on the end of the house should be to that of the front ones as the right face of the second cube in Chapter XVII (Fig. 84) is to the right one. The height of the windows in the "L" is made the same perspectively by carrying their measurements from the right front corner of the main house on lines vanishing to VP1. These lines lie on the invisible end of the main house, and from where they reach the "L" are continued along its front by lines running to VP2.

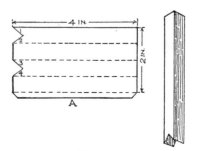

FIG. 121

The Chimney. — To better visualize this part of the house, cut and fold cardboard as in Fig. 121. Get the slope of lines 1, 2, 3, and 4 by laying the cardboard against the apex of the gable and marking around it. Stand this model on the roof in its middle, and after marking on the roof around it, cut out the space so marked and push the chimney down through the open-

ing until it projects the proper distance above the roof. Lay a pencil on the roof against the chimney (Fig. 122), and move it to the left without changing its direction till it coincides with the gable edge. This shows the gable edge and the oblique line where the chimney passes through the roof to be actually parallel. This oblique line, therefore, has the same vanishing point as that of the gable line, which is OVP1. The top of the chimney front and the line below it (AB, Fig. 123) are parallel to the

Fig. 122

eaves and ridgepole. Turn the model (Fig. 120, end view) and see that the top edge of the chimney is parallel with the horizontal lines on the house end, which we have already drawn to

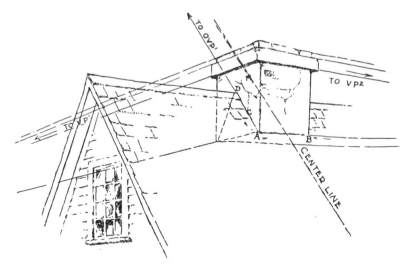

Fig. 123

VP1. A pencil held horizontally and moved slowly up in front of the model will help to see this as will marking the chimney in the model off into bricks (Fig. 124).

Drawing the Chimney. — Continue on the roof the center line used for the door (that is, vanish a line from its top to OVP1),

and mark down from the ridgepole on this line half the thickness of the chimney (judged by the eye). Draw a line through this

A- PLAN OF CHIMNEY.
B- PROFILE SHOWING ORNA-
MENTAL BAND AT TOP.

FIG. 124

point toward VP2, and on it set off to right and left perspectively equal distances for the breadth of the chimney (AB). Draw line C to OVP1. Where it crosses the ridgepole (D) is the middle of the chimney from front to back. Make the far half of the chimney proportionately as much smaller than the near half as the far half of the house end is smaller than its near half.

The projecting band at the top of the chimney is shown in plan and profile in Fig. 124. Its perspective is drawn as are projecting book covers. Be careful to represent the backward projection on the farther side.

The Steps. — For these the detail drawing (Fig. 125) is first made. The height under the threshold of the door is a little less than two feet, or about one third of the height of the eye — enough for three steps. Divide the vertical line under the near edge of the door therefore into three equal parts, and draw lines of indefinite length to VP1 through the four points of division. On the lower line, B, mark off the proper distance (as four feet), which

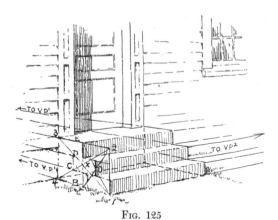

FIG. 125

may be estimated by comparison with the windows on the end of the house (their width being parallel with these lines, and usually about three feet). Divide this distance into perspective halves. A vertical line from the near end of line B, cutting line E in Point 2, completes the rectangle, 1–2–3–4, the middle of which can be found by its diagonals, giving the perspective

halves required. (See A, Fig. 126.) The further half is for the wide top step. The near half of the rectangle can be divided again in the same way for the two lower steps. Where the vertical line from the near end of B cuts line C is the upper near corner of the lower step. A vertical line through O will mark its width on C, and continued to cut D forms the nearest front corner of the second step.

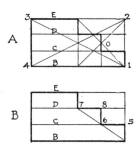

Fig. 126

Another method of sketching the steps is shown in Fig. 126. When the first step has been drawn its diagonal is continued through 6, cutting line D in 7, and forming the diagonal for the second step, which is completed by continuing line D to cut a vertical from 6 in 8. This can be continued for as many steps as needed. The diagonal can also be used as a test for steps drawn by the first method.

The long edges of the steps vanish in VP2, and are cut alternately by lines vanishing in VP1 and vertical lines.

The Dormer Window. — This is constructed in principle like the gable of the roof. The detail drawing (Fig. 127) should be carefully studied, and drawn separately if desired, before sketching the window on the house.

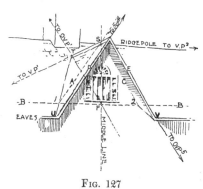

Fig. 127

On the center vertical line of the house front continued upward, mark the height of the dormer from line B. (In this case it is not so high as the main house.) Through this point (S) the dormer ridgepole is drawn to VP1, and cut by the oblique middle line on the roof (in point T). The width (1–2) of the dormer is then marked perspectively to right and left on line B. Through these points (1 and 2) the "valleys," or meeting lines of the dormer with the main roof, are drawn from the roof end (T) of the dormer ridgepole to the edge of the eaves (points

U and V). From these points the edges of the dormer roof projection run parallel respectively to A and C.

Oblique Lines in the Dormer. — These two lines A and C, though oblique to line B, are in the same vertical plane (as the gable lines F and H in the main house are in the same plane with line A in Figs. 111 and 112). Therefore draw a second vanishing trace for oblique lines vertically through VP2, and continue A upward until it cuts this trace in OVP4, to which draw the edge D. The other oblique edge (E) vanishes in the same vertical below VP2.

When experience has been acquired, such oblique lines can be satisfactorily drawn without actually finding their vanishing points. Such convergences are generally estimated in practical work. But estimates are much more valuable when made with a knowledge of methods by which they can be definitely determined.

Chapter *XXIII*

A BUILDING FROM THE PHOTOGRAPH OR A PRINT

THE example given in Fig. 128 is from the old church of San' Apollinare in Classe, near Ravenna.

The beginner may draw this as a preparation for his

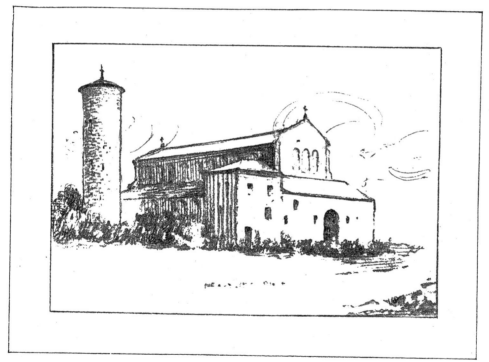

Fig. 128

next work, which should be the drawing of a building or part of one from a print of his own selection.

Making a Selection. — This choice should be carefully made, care being taken to secure unity, or an appearance of one whole

thing having a center of interest and parts which are subordinated, or catch the eye less quickly. It should be well placed in its rectangle (Chs. VIII and XXI). For instance, the tall tower in Fig. 129 needs a margin that is longest vertically, and quite narrow, to produce a harmony of lines. The smaller buildings with it give variety, and by a contrast which is not too great emphasize its height, being subordinated that the tower may remain prominent in the composition.

FIG. 129

In Fig. 130, on the other hand, the long, low mass of farm buildings set well back into the pic- ture re- quires a rectangle that is longer horizontally.

FIG. 130

Some of the different selections that may be made from one print (Fig. 131) are shown in Fig. 132. The beginner can by such means obtain an example simple enough to be within his powers and often a better composition.

Drawing from the Print. —As soon as the place of the building on the paper is fixed, *the level of the eye must be determined and marked*, and *the vanishing points* of the principal sets

FIG. 131

of horizontal lines *must be found on that.* It is of course easier for the beginner to use such vanishing points as are near enough to be marked. But the student must fully understand that a point too far away to be marked can be *mentally* located, and the lines drawn toward it with closely approximated accuracy. The essential thing is to *have the position of such a point clearly thought out,* — even, for instance, as specifically as that it is " the width of the board," or " three times " that, distant. The power to do this accurately grows rapidly, and can be attained by students of moderate ability. It is one object of this study.

FIG. 132

Rendering from the Print. — As more complex sketches are made, certain parts may be expressed in color (that is, covered

FIG. 133

with a tone of pencil lines), as was done with the title space of the books in Chapter XIX. The doorway, windows, and shaded sides of the buildings in this exercise (Fig. 131), are examples of this. Such use of color is intended sometimes to attract the eye to the most important or interesting parts, or to bring out the beauty of such details as the majestic forms of the trees in A, Fig. 132.

FREEHAND PERSPECTIVE

The Comparative Simplicity of Perspective. — By experience in mentally grouping each new vanishing line with the set to which it belongs, the perspective of apparently difficult studies becomes simple. In Fig. 133 a seemingly complex group of buildings is shown to need but four vanishing points for nearly all of its lines.

Chapter *XXIV*

TYPE FORMS HELPFUL IN UNDERSTAND-ING THE HOUSE[1] — THE SQUARE FRAME

THE Model. — The model for the square frame is six inches on a side, and one inch square in section. Looked at from the front, it appears as two concentric squares one inch apart (Fig. 135). It is placed with one set of long edges vertical, and the other horizontal and making angles of sixty degrees to the left with the picture plane (Fig. 136).

In considering its shape it may be first regarded as a Plinth, or one-inch rectangular slice from a six-inch cube, and therefore one sixth of the cube in thickness (Fig. 137).

[1] Some of the geometric solids here and later given may be omitted at the discretion of the teacher. Those selected for study should be such as to supply any deficiencies in the student's mastery of the subject.

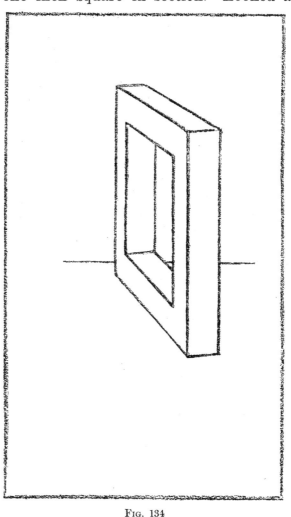

Fig. 134

85

Drawing the Model. — The lines of this solid may be drawn and its proportions established in the same manner as those of

FRONT SIDE
FIG. 135

the cube (p. 54). Remember to place the eye level at once after drawing the first vertical edge. Like the cube, these type forms should be lightly sketched first and later rendered with the firm, simple lines appropriate to them. Being more complicated than the cube, their visible edges may, if necessary, be strengthened (that is, be drawn as they would finally appear) as soon as determined, to avoid confusion.

The inner square of the frame may next be marked out on the plinth (Fig. 137). To do this place points one sixth of the front vertical edge from each end, and from them vanish lines to VP1. In these lines the edges A and B of the inner square must lie. By the front view (Fig. 135), we perceive that the corners of the inner square lie in the diagonals of the outer

FIG. 136

FIG. 137

one. One diagonal, C, will mark two corners (*x* and *y*) of the inner square. Its other two corners are found by drawing the vertical edges of the inner square, from corner *x* down to line B and from *y* up to A.

If this inner square were cut out, leaving a frame, parts of the inner thickness of the frame could then be seen. Of this inner thickness, line D (Fig. 138) lies in the back surface of the frame, parallel to B, and at actually the same height. Hence it can be started at a point (*z*) on the right hand vertical edge of the frame, obtained by drawing line E from the near end of B to VP2. This may be called carrying line B " around

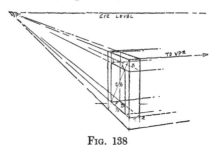

FIG. 138

the corner." From this point *z*, D is drawn to VP1. The lower inner edge (F) at the back is parallel to the outer thick-

ness edges, and therefore can be drawn to VP2, cutting off line D. A vertical line from where D and F meet completes the inner thickness.

Tests. — The correctness of this drawing can be tested by adding the invisible portions, shown by dotted lines in Fig. 138. Thus if line A be carried around the corner, giving the invisible edge H, the inner invisible edge I should cut it in line G continued.

FIG. 139

The Application of Type Form Principles. — The application of the foregoing work to the drawing of such parts of the house as windows and doors may be seen in Fig. 139, where the inner edges of door and window frames converge with the set of horizontal lines at right angles to the door. For instance, lines A and B converge with the dormer eaves and other lines tending to VP2, and line C vanishes with the set to VP1.

Chapter *XXV*

THE SQUARE PYRAMID AND SQUARE PLINTH

T**HE Models.** — The plinth is two inches high and six inches square: the pyramid four inches square at base and eight inches high. The models can be made (Fig. 141). If made, note that in order to secure the required height in the completed pyramid, the length (*xy* in Fig. 141) of each triangular side piece of the pyramid pattern is measured from *xy* in Fig. 142, where the true length of a side face is shown. The face *x–y–z* in Fig. 142 leans back, making *x–o* foreshortened.

Position. — The plinth rests on one square face, with its sides at angles of thirty and sixty degrees with the picture plane (Fig. 142). The pyramid stands on the plinth,

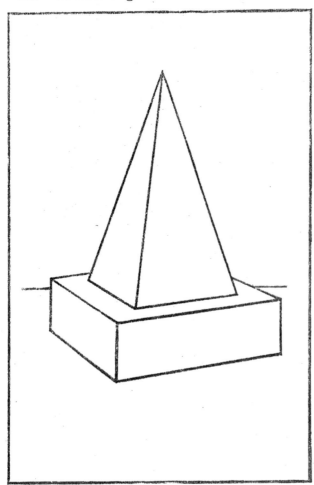

Fig. 140

88

with its base parallel to and equidistant from the edges of the plinth top.

Drawing the Models. — Proceed with the plinth as with the cube, remembering that its height is but one third as much as the cube in proportion to its breadth.

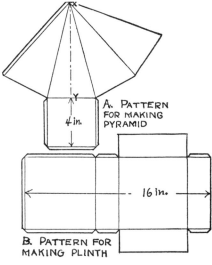

A. PATTERN FOR MAKING PYRAMID

B. PATTERN FOR MAKING PLINTH

FIG. 141

For the pyramid base, one perspective sixth must be marked from each end on line AB (Fig. 143). To get

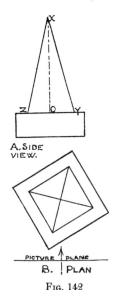

A. SIDE VIEW.

B. PLAN

FIG. 142

these points (1 and 2) a diagonal of the side ABCD can be used (as in Ch. XX). The vertical edge, AC, being unforeshortened, is first divided into six actually equal parts. Lines from the upper and lower division points (8 and 9) to VP1 transfer these divisions proportionately to the diagonal, AD. From the diagonal they are transferred by vertical lines to the edge AB. (See also Fig. 144.)

Or a diameter through the center (O) will divide

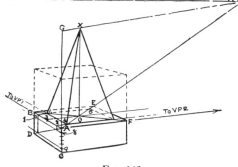

FIG. 143

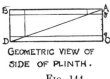

GEOMETRIC VIEW OF SIDE OF PLINTH.

FIG. 144

AB into perspective halves at 3, when each half can be divided into thirds by the eye. One method can be used to prove the other.

From points 1 and 2 draw lines to VP2. Where they cut a diagonal, as AE, will be two corners (4 and 5) of the pyramid.

Lines to VP1 through these points will give the two other corners (6 and 7), and complete the base of the pyramid.

The apex of the pyramid will be vertically over the center of its base, point O. On a vertical line from O must be measured

the perspective height of the pyramid. Its actual height is four times that of the plinth. The nearest corner of the plinth is convenient to use, hence from A the vertical line is continued, and four times AC is measured on it, giving AG for the pyramid height as it would appear at that point. If now this height, AG, could be moved back on the diagonal AE to O it would appear to shorten as moved. Its top would describe an actually horizontal line above AE, that is, a line parallel to it, consequently vanishing to the same point. Therefore continue the diagonal AE to the eye level, giving VP3, and draw the parallel line from G to VP3, which will mark on the vertical from O the desired perspective height at x. Complete the pyramid by drawing its oblique edges to the corners of its base.

FIG. 145

Applications. — The difficulty of making a church spire or a tower (Fig. 145) " stand true " will be readily recognized. The use of the diagonals (AB and CD) will aid in placing its axis and apex.

Any upright rectangular object with equally sloping sides is easily constructed on the same principle, as the grape basket in Fig. 145a. If such an object is leaning, the meeting of its corners continued can still be used as there shown.

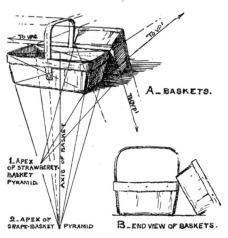

FIG. 145a

Chapter *XXVI*

THE SQUARE FRAME LEANING ON THE RECTANGULAR BLOCK — A PROBLEM FOR ORIGINAL STUDY

THE Models. — These have already been described on pages 48 and 85, respectively.

Position. — The block rests on one long face, with its square ends making angles of sixty degrees with the picture plane.

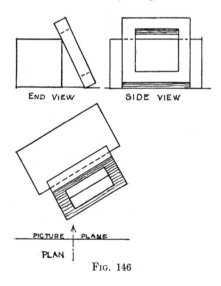

 END VIEW SIDE VIEW

PICTURE PLANE

PLAN

Fɪɢ. 146

The frame leans against the block, equidistant from its ends, and with a distance equal to half the width of the block between its lower edge and the block.

Chapter *XXVII*

CYLINDRICAL OBJECTS WHEN NOT VERTICAL

A LTHOUGH in Chapter III the cylinder held horizontally was mentioned, we have only *studied* cylindrical objects when vertical. In this position they have been found symmetrical, the ellipses and the axis (which is the middle from end to end) being at right angles to each other. To study

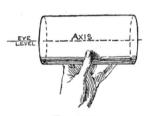

FIG. 147

them in other positions begin with the cylinder model held horizontally, with its middle on the eye level, and its ends equally distant (Fig. 147). It will be readily seen that the ends now appear at right angles to the axis, as when the object was vertical. Turning it a little so the right end can be seen (still keeping it horizontal and at the eye level), it will be observed that the apparent directions of the axis and ellipses are unchanged. (The axis being a horizontal line and at the eye level remains apparently horizontal, and the ellipses still appear vertical. The further ellipse has become a little shorter and rounder, and the side boundaries, like all parallel receding horizontal lines, appear to converge to the eye level.)

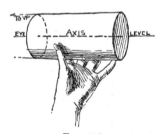

FIG. 148

Now lower the model, keeping it turned away, till it rests a foot below the eye on some horizontal support (as the box in Fig. 149).

The side boundaries and the axis, being below the eye, vanish upward to a point on the level of the eye. They will continue

to vanish to the eye level, whether below or above the eye (B in Fig. 149), as long as the cylinder is kept horizontal. The ellipses should now be examined to see if in this position they appear, as formerly, to be at right angles to the axis. Do this first with the head erect as usual, looking with care, and deciding mentally. Then try inclining the head (in this case of A, Fig. 149, to the right and downward) to bring the face in relation to the model as it would be if both were vertical. Two pencils held in the shape of a letter T, held in front of the cylinder (as in Fig. 150) will help

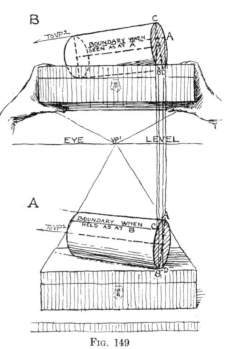

Fig. 149

make sure that the axis of the cylinder and the long diameters of its ellipses unmistakably appear at right angles to each other.

To understand how this can be the case, hold the

Fig. 150

cylinder again at the eye level, as in Fig. 151, and with a pencil mark on it the points (A and B) where the side boundaries meet the ends of the ellipse. Lower the cylinder

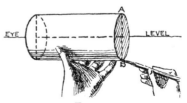

Fig. 151

again (Fig. 152) when it will be seen that these points are not now at the ends of the ellipse, and that the line AB is not now its long diameter. It has now a new long diameter, CD, at right

93

angles to the axis in its new apparent direction; and also new side boundary lines from C and D toward the vanishing point.

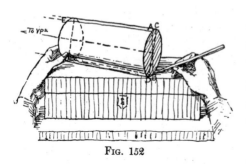

FIG. 152

As the long diameter is always at right angles to the axis, it *must* change its position when the object is moved so that its axis appears changed in direction. We see therefore that *the long diameter is movable.*

These experiments may be tried with other cylindrical objects, as a tumbler, or the flower pots in the next chapter. The leaning dish in Chapter VIII, and the tilted cover in Chapter X are examples. It will invariably be found that, *provided the circular details of a cylindrical*

FIG. 153

object are actually at right angles to its axis, they will appear so whatever the position of the object. Consequently, *cylindrical objects always appear symmetrical.*

Tests. — A drawing of such an object may be tested by turning it to bring the object in question vertical (Fig. 156, Ch. XXVIII), when errors in symmetry will be more apparent.

A wheeled vehicle (Fig. 153) is a common illustration of this principle; also a clock (Ch. XXXI) and the round arches in Chapter XXXII. Others will readily occur to the student. Flowers (Fig. 154) are striking examples, and many awkward drawings of flowers are so because drawn in ignorance of this beautiful and simple principle of the symmetry of the cylinder.

FIG. 154

Chapter *XXVIII*

A GROUP OF FLOWER POTS

AS with previous examples, drawing this exercise is optional with the student, according to his proficiency. But he should compose a similar group, that is, having in it at

Fig. 155

least one cylindrical object not vertical. And he should take especial pains to secure the symmetry of such nonvertical objects.

The illustration (Fig. 156) shows how this symmetry may be tested by turning the group.

A.

B. SHOW-ING A TURNED To BRING LEANING SAUCER VERTICAL

Fig. 156

Chapter *XXIX*

THE CIRCULAR FRAME IN A SQUARE FRAME

T HIS is an example of rectangular and cylindrical forms in the same object. The explanation should be carefully studied, and the exercise drawn unless the student is experienced.

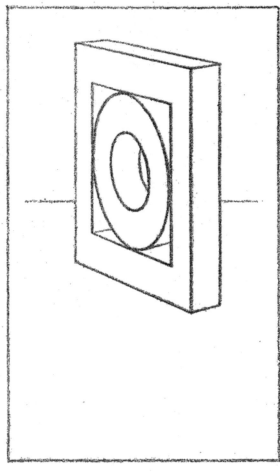

The Circular Frame. — After the square frame (Ch. XXIV) is drawn, look at the model from the front (Fig. 158), and note that the outer surface of the ring touches the square frame *at four points only* — where the diameters of the square cross it (A, B, C, and D). These diameters, being parallel respectively to the sides of the square, are represented in the perspective by a vertical line, and a line vanishing in VP1, both passing through the true center O, at crossing of the diagonals. Through these four points the outer edge of the circular frame must pass.

Fig. 157

96

Disregarding at first the opening in it, the circular frame may be temporarily thought of as a slice from the cylinder, one inch thick, and therefore a very short cylinder, with an axis only one inch long. As placed within the square frame (Figs. 157 and 159) its axis and side boundaries are parallel with the short edges of the square, and its actual centre and that of the latter coincide.

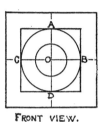

FRONT VIEW.

FIG. 158

Hence we may draw its axis from this center (O) to VP2. Its circular outer edge will be seen as an ellipse at right angles to this axis, and passing through the four points A, B, C, and D, previously found. As the short diameters of such ellipses always appear to lie in a line with the axis of

FIG. 159

the object (Fig. 160), *the axis line will give the apparent direction of the short diameter of the ellipse.* (Here the beginner is advised to turn the paper round, bringing the axis as a vertical line, the better to secure the symmetry of the cylindrical part of the model. See Fig. 161.)

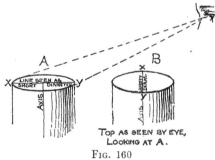

TOP AS SEEN BY EYE, LOOKING AT A.

FIG. 160

To obtain the length of this short diameter, slightly curved lines, perpendicular to the short diameter, are sketched from B to the right and from C to the left, giving x and y for the extreme front and back of the ellipse.

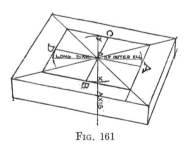

FIG. 161

Now (since an ellipse is always symmetrical) the longest dimension or long diameter of this ellipse is *not* on the vertical line through A and D (Fig. 159), but is on a line at

right angles to x y, and *through its apparent middle from front to back;* making one end fall in front of D, and the other back of A. It will also be a little in front of O, the true center of the circle, and a little longer than A D, but not touching the frame. Mark lightly and accurately this apparent middle and sketch the long diameter through it. Mark the ellipse ends by sketching rounded curves, from A back and from D forward, making them symmetrical on the long diameter, and equidistant from the axis. Complete the ellipse by connecting these ends and sides, correcting if necessary, till the ellipse is perfect.

For the inner ellipse proceed as with the top of the cylinder in Chapter IV, remembering to make its proportions as shown in Fig. 158; also that the perspective halves of the short diameter are already found by the true center, O. Or four points for the inner circle (e, e', f and f', Fig. 161a) may be found by the method given for concentric circles in Chapter XX. Thus points E and F are set off their proportionate height on the nearest vertical edge xy, and lines vanished from them to VP1. Where these lines cross AD are e and f, the two points for the inner circle corresponding to A and D in the outer circle. For the points on its horizontal diameter (e' and f', corresponding to C and B in the outer circle) vertical lines are drawn from the points (1 and 2) where the vanishing lines cross the diagonal.

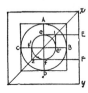

Fig. 161a

The inner ellipse is then constructed as was the outer one.

The side boundary lines of the circular frame may now be drawn to VP2, when there will remain only its inner thickness to draw. The edge of this is an inner circle on the back of the frame, actually like the inner one in front. Draw lines (E and F') from the ends of the front inner ellipse to VP2. These may be called side boundary lines of the cylindrical opening; and their convergence measures the smaller length of the desired back ellipse, which lies with its ends in these lines as does the front one.

CIRCULAR FRAME IN A SQUARE FRAME

The round arch (Fig. 162, also Ch. XXXII) is an interesting application of this principle. Errors in drawing these and kindred forms (B in Fig. 162) so common with beginners are easily avoided when these principles are understood.

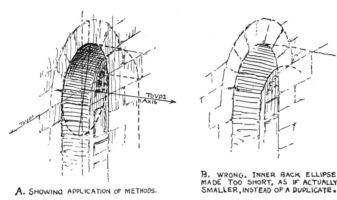

A. SHOWING APPLICATION OF METHODS.

B. WRONG. INNER BACK ELLIPSE MADE TOO SHORT, AS IF ACTUALLY SMALLER, INSTEAD OF A DUPLICATE.

FIG. 162

Chapter *XXX*

A ROUND WINDOW

THIS exercise (Fig. 163) and the methods of sketching it should be carefully studied, and if necessary it should be drawn. After this the student should sketch a similar example from a building or photograph.

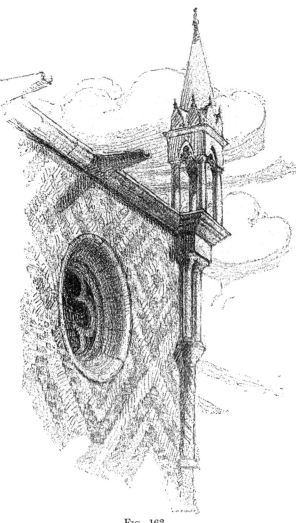

FIG. 163

Having drawn the straight-line part of the exercise, the round window is next to be considered. This is actually a cylindrical opening in the wall. Being above the eye, the circles of the window appear as slanting ellipses like the cylinder ends in Fig. 149 (Ch. XXVII). To make sure that the slant of these ellipses shall agree with the straight-line part of the building, the axis of this cylindrical window is used. This axis is actually at right angles to the wall, and

is therefore parallel to the lines already vanishing in VP1. Hence the apparent middle of the window ellipse (O in Fig. 164) is first located, and the axis is drawn through it to VP1, extending forward indefinitely. The long diameter (AB) is sketched at right angles to the axis, and the short diameter (CD) is set off on the axis line. The ellipse is then drawn through these four points. The inner ellipses of the window are shorter as well as farther back than the outer one.

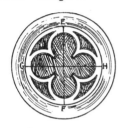

A. FRONT VIEW

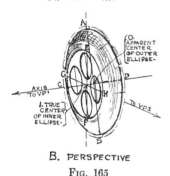

B. PERSPECTIVE

Fig. 165

For the partial ellipses of the quatrefoil, the actual center of the inner ellipse (1 in Fig. 165) must be marked, and through it a vertical line (EF) and a horizontal one (GH, vanishing in VP2) drawn. The real centers of the quatrefoil circles fall each on one or the other of these lines. Their long diameters (a little in front of these real centers) are parallel with the other long diameters of the window.

This quatrefoil is especially an example of objects which should in practice be sketched freehand first, and afterward tested by the constructive methods here given. (See Introduction.)

Chapter *XXXI*

THE CLOCK A PROBLEM

THIS example (Fig. 166) is given as an aid in rendering, though it may be drawn first if desired.

The Model. — Any clock containing rectangular forms and the usual circular face will serve as the model. It should be placed above the eye.

Conditions. — Unlike problems in general, this drawing may be made from the object, but must be done without assistance. The aim is to test the student's ability to apply the principles taught in the last few chapters.

FIG. 166

102

Chapter *XXXII*

THE ARCH

THESE arches from the cloister of St. Paul's Without the
Gates, at Rome, also illustrate the symmetry of the
cylinder, and can be drawn by the same method as

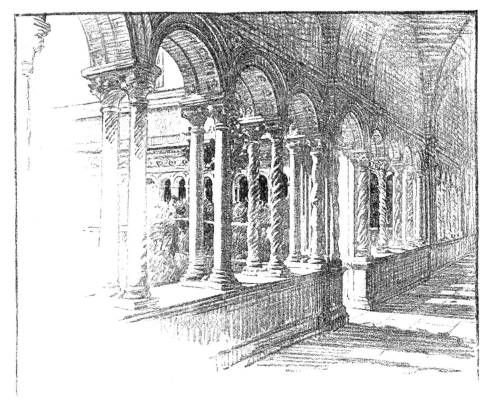

Fig. 167

the round window in the last chapter. (See Ch. XXX.) They
are semi-cylinders and their openings are semicircles (Fig. 169).
The semicircles are sketched on a horizontal line (A) which,

being above the head in this instance, vanishes downward (Fig. 168). The true centers of the semicircles are on this line, and from

FIG. 168

these centers the axes are drawn, vanishing with other lines to VP1. The joints of the stones forming each arch, being lines really tending to meet in its true center, are so drawn in perspective.

Pointed arches, and other modified forms can be readily drawn on the same principles here used.

The student should draw this exercise unless experienced, when he should instead select a print of artistic interest, illustrating the same principle, and make from it a careful and expressive sketch. In either case, he should follow his first drawing with another involving the use of this principle, from a building.

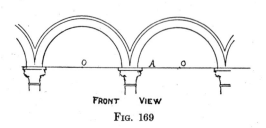

FRONT VIEW

FIG. 169

Chapter *XXXIII*

INTERIORS — A ROOM PARALLEL TO THE PICTURE PLANE

THE **Cube as a Model.** — With a penknife loosen one face of the cardboard cube, and turn it back or take it off. Place it within a foot of the eye, with the opening parallel to

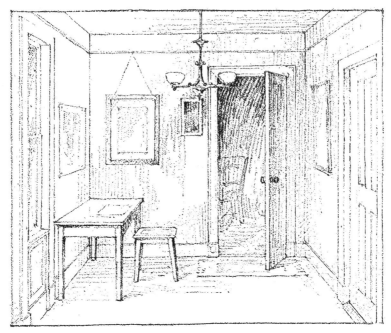

<center>Fig. 170</center>

the picture plane, and the eye level a little less than two thirds of the way up. If desired, the windows, doors, rug, and pictures may be marked with a pencil on the inside of the cube. It now serves to illustrate the room shown in Figs. 170 and 172, as the cubes and prism illustrated a house in Chapter XXII. In this room the floor, ceiling, side walls, and all details on their surfaces

<center>105</center>

(as the window, the side door, and the rug) are foreshortened; while the side edges converge to VP1 directly in front. The back wall and all surfaces parallel to it (as the end of the table and one side of the stool), being parallel to the picture plane, appear in their true shape.

Directions. — This example (Fig. 170) should be drawn by the student if a beginner. After this the end of a room, also with its farther wall parallel to the picture plane, should be drawn from memory or invention.[1] A hall, a kitchen, a street car, or a piazza will be recognized as especially adapted to such views.

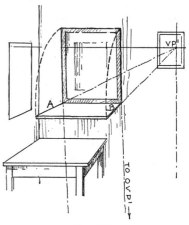

The Apparent Width of the Sides. — To aid in estimating this, recall the appearance of the most foreshortened side of the cube in Chapter XVI. This estimate may then be tested by pencil measurement of the cube model.

The Pictures. — Although the picture on the right wall is inclined

Fig. 171

slightly forward, its sides are still parallel to the picture plane; and therefore appear in their true direction and shape. With the picture on the back it is not so. Its top is slightly nearer to us than its lower edge; and must therefore appear longer, making the sides appear to converge downward (though almost imperceptibly). To determine the direction of this convergence, revolve it forward on its lower edge in imagination until horizontal (Fig. 171). It will at once be seen that the sides (A and B) in this position are parallel with the lines already vanishing in

[1] It may be asked why memory or inventive drawings should be advised before study from a room. But in this case we meet a subject of which all have something in memory; and drawing from memory when possible (when one has something remembered) is not only far pleasanter, but much less laborious. The object or place itself presents to a beginner a confusing mass of detail, much of it not needed for the drawing. The student must make later many drawings from the place to accumulate knowledge; but will always do his most free and individual work from this knowledge, not directly from the object.

VP1. If now the picture should be slowly revolved upward, the converging point for the sides would descend as the picture rises. As the picture is not moved sidewise at all, this point of convergence (OVP1) can only move downward in a vertical line from VP1 like the roof ends in Chapter XXII. When the picture is returned to its original position, it varies but slightly from the vertical; consequently OVP1 is too far away to locate

and the vanishing of its sides must be estimated. Make sure it is slight enough, and toward a point vertically under VP1.

An Open Door. — So far we have found but one vanishing point on the eye level. If we begin to open the farther door, its horizontal lines will instantly acquire a vanishing point, but at an infinite dis-

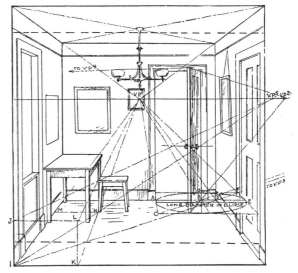

Fig. 172

tance. In proportion as the door swings toward being parallel with the sides of the room (that is, with the direction of seeing), this vanishing point will move inward. When the door becomes quite parallel with the walls of the room, this point will coincide with VP1. If the door is swung still farther back, this point moves on toward the left. The apparent width of the door thus opened may be measured by an ellipse on the floor (Fig. 172) representing the path of its near corner as it swings in a circle. The short diameter of this ellipse is proportioned to the foreshortening of the floor in which it lies. It can also be found by the use of lines parallel to the floor diagonal (Fig. 173). From this diagram it is seen that since the floor is a square, its diagonal is a line at 45° with its sides. By lines at 45°,

107

distances into the picture can be measured equal to others parallel to the picture plane (Fig. 103, p. 65). In Fig. 173 (and perspectively in Fig. 172) AC is made equal to AB by drawing BC at 45°, or parallel to the floor diagonal.[1]

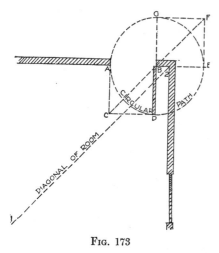

FIG. 173

It will also be noted that the thickness edges of the door, being horizontal and at right angles to its top and bottom, have their own vanishing point upon the eye level (VP4). Also the door knob is cylindrical, and its axis is parallel to these edges.

The Stool. — The proportion of the stool is found in the same manner as the height of the pyramid in Chapter XXV. The room may be considered as nine feet high, and the stool as approximately eighteen inches, or one sixth the height of the room. Mark any point (as H in Fig. 172) where it is desired to place it on the floor of the room. Its height cannot be compared directly with that of the room here, for we cannot determine where a vertical line from H will touch the ceiling. Therefore imagine the stool moved from point H in a straight line to any place on the front edge of the room, as I, where its height (IJ) can be measured by that of the room. If now it were moved back on this same line (IH), its top would move in a horizontal line directly over IH, that is, actually parallel to it, or vanishing in the same point on the eye level. Both lines (HI and one from J) may therefore be carried to this point VP5. The height of the stool, when placed at any point on the line from 1 to VP5 will be the vertical distance (as at H) between these lines.

The near side of this stool is now drawn in its true shape, and the parts at right angles to this side found by vanishing lines to VP1.

[1] The ellipse is made horizontal, as explained in Chapter XLIII.

Finally, to improve the composition some of the ceiling and a little of the floor are cut off, as shown by the dotted lines in Fig. 172. This gives a more generally favorable shape (Fig. 170) to the inclosure, and keeps the oblique lines from running to its corners, which should always be avoided. (See p. 116.)[1]

[1] See Chapter XLII for further consideration of a room parallel with the picture plane.

Chapter *XXXIV*

INTERIORS CONTINUED—A ROOM AT ANGLES TO THE PICTURE PLANE

THE Model.—The cube model may be prepared for illustrating this study by removing a side adjacent to the opening made for the previous study.

FIG. 174

Position.—The eye level and the distance from the eye are the same as in the last chapter. Place the model so that its receding faces make very unequal angles with the picture plane (B in Fig. 175). Both sides and the top and bottom are now foreshortened and their horizontal lines vanish respectively in VP1 and VP2 (Fig. 177).

Selection of Subject, and Use of the Picture Plane.—It will be seen that the room in Fig. 174 is the same as in the previous chapter. The difference is in the selection of subject-space, and in the consequent

relation of the subject-matter within that space to the picture plane. Thus in the last study, the extreme points (*x* and *y*) of the back wall of the room are equally distant from the picture plane as well as from the eye (A in Fig. 175). Therefore we could not, without absurdity, vanish the lines on this wall in either direction (A in Fig. 176), still less in both (B in Fig. 176). The only way to give a truthful impression of the

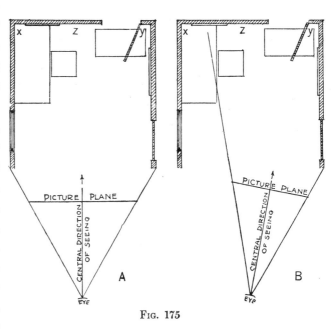

FIG. 175

back wall is to draw it in its true shape (C in Fig. 176), as was done in the last chapter.

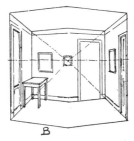

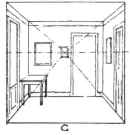

FIG. 176

But in the present exercise (Fig. 174) part of the room is left out. The central direction of seeing is therefore moved to the right, and with it the picture plane is turned (B, Fig. 175). Consequently the wall, *xy*, which was before parallel to the picture plane, now recedes from it. Hence the height of the room at the corner, being farther into the pic-

ture *and from the picture plane*, appears less than at the right and left; and all horizontal lines on both walls appear to converge.

In this drawing the rectangle incloses the parts of most interest and cuts off the awkward outer lines (Fig. 177). An

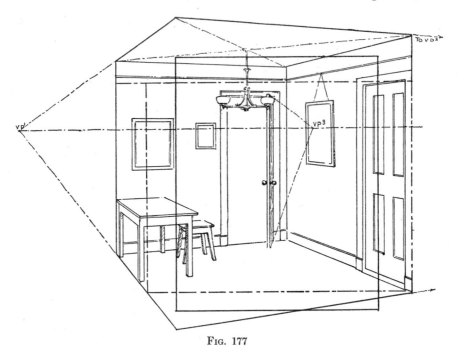

FIG. 177

alternate selection is indicated by dotted lines. This brings us to the consideration of a new point, namely:—

What to Include in a Picture. — This cannot be all that it is possible to see from any point, for the head can be turned to see all parts of the horizon circle. Such a view when painted forms a panorama, which is a continuous cylindrical picture surrounding the spectator.

It is evident that the legitimate picture must include, or cut out from what it is possible to see, only such a space as can be perceived by the eye in a single effort of seeing. It should leave out whatever cannot be seen without turning the head, or even noticeably moving the eyes. It is generally understood

that sixty degrees of the horizon circle is the most that should be taken, and that usually thirty degrees is better. The rule is that the greatest dimension of the selected space (whether height or width) shall not exceed the artist's distance from that dimension.

It will be seen by the diagram (Fig. 178) that this is equivalent to not exceeding sixty degrees in the picture. It is also apparent that it does not prevent the inclusion of objects nearer than that greatest width if they come into the picture space, as the table and part of the rug in this illustration.

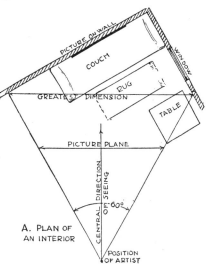

In conclusion it should be noted:

First. — *The picture plane is different for each new picture selection.*

Second. — *The picture angle should not be over sixty degrees, and is better less.*

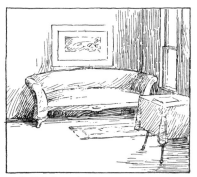

B. THE PART SELECTED FOR A PICTURE.

FIG. 178

Chapter *XXXV*

FURTHER STUDIES OF INTERIORS

THE student should copy carefully Fig. 179, always determining the level of the eye, and locating the vanishing points either actually or mentally. Note that the emphasis of contrast and interest is concentrated on the old-

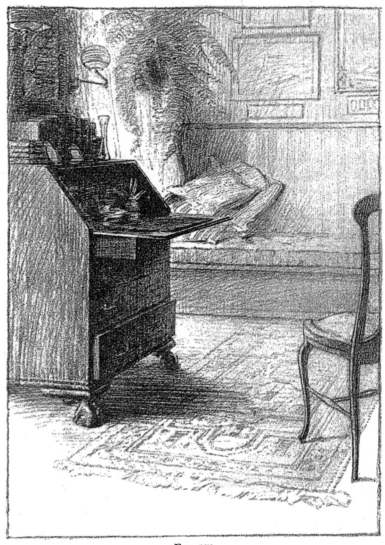

Fig. 179

fashioned desk while the details on the wall beyond it are very quiet. The settle comes forward more (that is, has more contrast and emphasis) than the wall, but less than the desk. The floor is purposely quiet in detail to aid in concentration of interest. The chair in the extreme right of the fore-ground is subordinated also.

FIG. 180

FIG. 181

Original Work. — Following the above copy several interiors should be drawn from the place. The finder should be used, and thumb-nail sketches (Figs. 180, 181, and 182) should be made to test the artistic value of the selection. Avoid equal angles in the principal sets of vanishing lines. If both should be drawn at forty-five degrees, or nearly that, the composition would have a stiff effect. The contrast between surfaces turned away much and others turned away little is generally pleasing. Should it be impossible to avoid equal angles of vanishing, relieve the stiffness by using details (as the sofa and window in Fig. 183) that

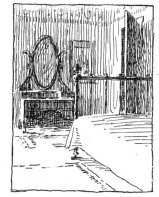

FIG. 182

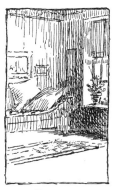

FIG. 183

are widely different in effect. The rug, being parallel with the sofa, assists further in overcoming the monotony. It is undesirable to show the floor and ceiling as occupying equal space in the picture; and it is usually better not to show both floor and ceiling. (Compare Fig. 182 with the same subject in Fig. 184.) A subject may

often be improved by cutting it with a different margin (Fig. 185).

Care should be taken to place the principal oblique lines of the study in such a relation to the margin or inclosing rectangle that they do not conspicuously point to the picture corners. The rectangle which bounds a composition is an orderly conventional

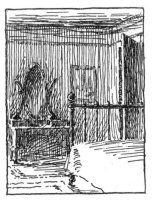

FIG. 184

shape, and hence unnoticeable, leaving the attention to be concentrated on the picture.

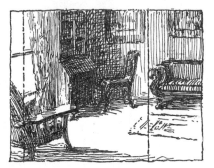

FIG. 185

Lines to its corners direct the attention there, and defeat this end.

Vignetting. — It is not necessary that an inclosing margin should always be

FIG. 186

used. The drawing may be vignetted, or blended off into the white paper (Fig. 186). This is less easy to do as the tendency of the irregular outer edge is to contrast sharply with the white paper, detracting from the effect of the more important central parts. The edge details therefore must be carefully " quieted," or rendered inconspicuous.

Interesting effects are often produced with a partial margin

line (Fig. 187). This is advisable if the center of interest is too near the edge of the paper to blend off well.

So many principles of perspective and of artistic rendering are included in the drawing of interiors that they form a most important division of the subject. In figure compositions they are constantly used, especially by the illustrator.

FIG. 187

Chapter *XXXVI*

A CHAIR

THE chair in Fig. 188, like most chairs is different from the stool in our first interior study (Ch. XXXIII) in that the sides are not parallel to each other (see plan, Fig. 189). Also the seat is a trifle lower in the back, so that lines B, B (Fig. 190) slope downward toward the back. But the chair is symmetrical on its center line (front view, Fig. 189), therefore the horizontal lines in its front and back are parallel, having a common vanishing point on the eye level.

Drawing the Chair. — After having planned its place on the

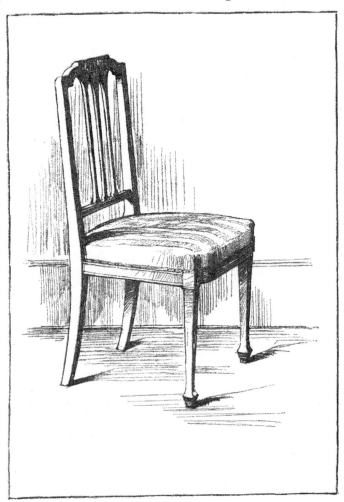

Fig. 188

118

paper and located the eye level, the next step is to take the direction of the front and side of the seat (lines A and B, Fig. 190). Leaving line A for the present we carry line B out, obtaining VP1. The feet, being on the horizontal floor, fall in lines vanishing to the eye level — on the right to VP1, and on the left in lines E and F. But as the chair sides are not parallel, line E, being turned away from the picture plane more than F, appears steeper, and its vanishing point, VP2, is nearer than VP3, to which line F vanishes. The near side of the seat, line A, being in the same vertical plane with line E (directly over it) must vanish where it will cut the vanishing trace of this vertical plane, which is a vertical line through the vanishing point of line E. (Compare the roof, p. 72.) Carrying out line A, therefore, to this vertical trace gives its vanishing point, OVP1, to

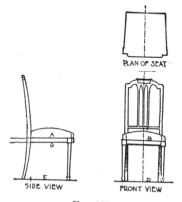

FIG. 189

which we vanish line G, which is parallel with A.

In the same way, line F, vanishing to a point on the eye level a little further away than VP2, gives the location of a vertical trace for OVP2, in which the other (invisible) side of the seat must vanish. The crossing of these invisible seat edges (H and I) and of the lines C and F aid in shaping the further leg.

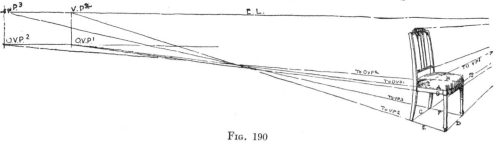

FIG. 190

As the seat is evenly slanted, OVP2 is on a level with OVP1.

All edges parallel to the front and back converge to VP2. The curving front of the seat and the curves of the back are drawn so their ends rest on a line to VP2. A rocking chair is

simply a chair (A, Fig. 191) placed on rockers (B, Fig. 191). The weight of its back generally tips it backward when at rest, hence

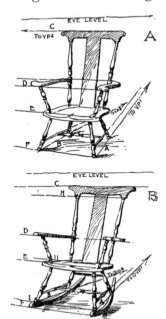

the usual appearance of a rocking chair is that of an ordinary chair plus its rockers. In B, Fig. 191, lines A and B, which above are actually horizontal, here actually incline downward at the back; and must vanish to a point below the eye level (like A, G and H in Fig. 190). The seat and arms are more foreshortened, and the back less erect. But the horizontal lines C, D, E, F and their parallels, remain actually horizontal, and vanish to the same point as in A. The directions of the slanting back, the legs and the arm supports should be carefully taken, remembering that their ends and ornamental details (as G, H and D) fall in lines to VP2. In sketching straight guide lines for the rockers, recall

Fig. 191

that they are farther apart in front, to agree with the sides of the seat. The lines where the cylindrical rungs enter the legs are actually *modified* circles, hence they will be seen as shapes modified from the elliptical, and should be carefully considered and drawn.

Following this, the student should choose and draw at least one other piece of furniture. Selection should be made of something interesting in itself; that is, well designed and constructed, and agreeable in association. In chairs the old-fashioned rush or splint bottom ones, the wooden rockers of our grandmothers, the beautiful examples by Chippendale, Sheraton and others of the colonial period, and good examples of modern mission shapes may be mentioned as among those satisfactory for study. If one is fortunate enough to get a really fine old cradle, it is a most instructive subject, as is an antique desk or a tall clock.

Chapter *XXXVII*

THE HEXAGONAL PLINTH IN TWO POSITIONS

THE student should draw this example from the objects, following the directions here given; and should then sketch them from memory, as by the general directions in Chapter XI.

The Model.— This can be made from cardboard according to the diagram (Fig. 193). For the first position it should be placed about three feet from the eye and nine inches below it, and with two vertical faces parallel with the picture plane.

The Geometric Hexagon.— This should be constructed first. Divide the line AB (Fig. 194) in halves, drawing

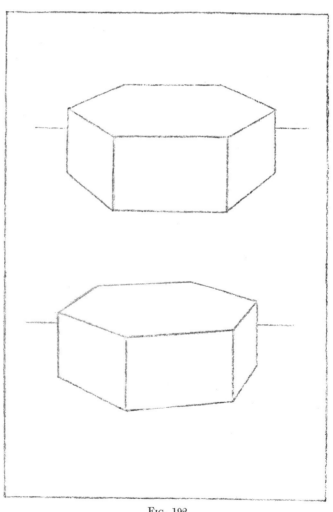

FIG. 192

a perpendicular at the point of division. Measure the distance
AB, taken on the pencil, from B against the perpendicular.

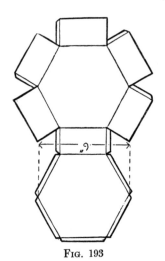

Fig. 193

Where it falls (at O) will be one corner
of an equilateral triangle (AOB) which
will form one sixth of the desired hexa-
gon. Sketch vertical lines of indefinite
length from A and B, and cut them by
continuing the sides of the equilateral
triangle (AO and
BO) to D and C,
then draw DC. The
constructive rec-
tangle ABCD, which
we have now com-
pleted, will be al-
ways essential in
drawing the perspective of the hexagon.
Its diagonals (A and B) will form two di-
agonals of the hexagon, and its center (O)
will be the center of the hexagon. The

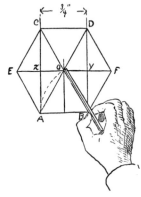

Fig. 194

other diagonal, EF, is drawn through O parallel to the rectangle
ends, half on each side of the center. Its length should be tested
by that of the diagonals already found. The other four sides
complete the geometric hexagon ABCDEF.

Drawing the Hexagonal Top. — The rectangle ABCD (Fig. 195)
is drawn first. Although it is actually nearly twice as long as
its width it will be found to appear less than half as long. The
diagonals of the rectangle will in perspective, as in the geo-
metric view, form two diagonals of the hexagon. The other
diagonal, EF, is set off on a line of indefinite length through
their crossing. Looking at the diagram, it is observed that the
sides of the rectangle (AC and BD) and its middle (O) divide
this diagonal (EF) into four equal parts at x, O and y. In the
perspective drawing (Fig. 195), the two middle fourths (xO and
Oy) are seen to be already measured. Since these fourths are

all equally distant from the picture plane, they appear equal, and are so set off from x and y. The hexagonal top is completed by drawing its last four sides.

The Thickness of the Plinth. — The front face of this thickness, being parallel to the picture plane, is drawn in its true shape. The lower edges of the other two faces are parallel to the receding horizontal edges (AE and BF) above them, and will therefore vanish with these edges respectively to VP2 and VP3. Vertical lines downward from E and F will complete the plinth.

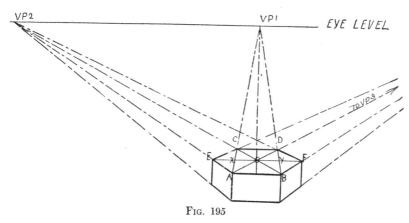

FIG. 195

A Test for Vanishing Lines. — The other two diagonals and the receding back edges of the hexagon are in reality each parallel to one or the other of the two sets of vanishing lines just drawn. Therefore when carried out to the eye level, they should meet respectively in VP1 and VP2 if the drawing is correct.

The Hexagonal Plinth Slightly Turned. — For this drawing turn the model so its front face will make an angle of thirty degrees with the picture plane (B in Fig. 196). Draw the constructive rectangle, ABCD; taking with the pencil the direction of the front edge and of the imaginary left side (AC in Fig. 196)[1] of the rectangle. Take especial pains to have these lines correct in direction

[1] Corresponding to the receding edges (2, 2) first drawn in sketching the cube.

and length, as an error here causes a particularly unpleasant representation. In vanishing the back edge with the front one be careful to keep it also tending upward.

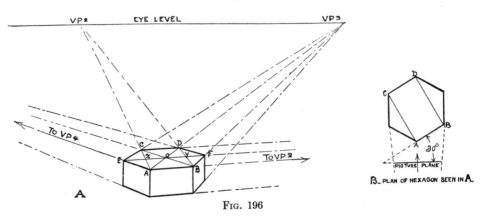

FIG. 196

B. PLAN OF HEXAGON SEEN IN A.

The vanishing point (VP2) of these front and back edges is so far away that their convergence will naturally be only

A. WRONG. LINES 1, 2, 3 AND 4 DO NOT CONVERGE TO THE EYE LEVEL.

B. WRONG. LINES 1, 2, 3 AND 4 ARE TOO STEEP. HEXAGON APPEARS TILTED.

FIG. 197

estimated. Hence the necessity of *locating definitely in mind what cannot be seen* — that is, the vanishing point, not only of these two lines, but of their parallels, the diagonal EF and the lower edge of the front face.

In this position the last diagonal, EF, is in perspective, and therefore its four actually equal divisions will appear decreasing in size, or *perspectively* equal. Consequently, if the work so far done is correct it will be found that the space xO is (almost imperceptibly) greater than $O y$, because a little nearer. Hence Ex should be set off a little larger than xO, and yF a little smaller than $O y$. Similar cases, as the cylinder top in Chapter IV, and the concentric circles in Chapter XX are readily recalled.

Testing the Drawing. — The test used for the other drawing of the plinth is equally effective here. It is more needed here,

since the vanishing point for one set of lines has not been actually found. But if these lines have been carefully thought out as to direction, the errors will be found encouragingly slight.

The test of placing the eye at the vanishing point (Ch. XVII), to sight back along the lines which should converge to them, is especially applicable here.

Chapter *XXXVIII*

INTERIOR WITH A TILED FLOOR

THE plan of this floor is shown in Fig. 199. As drawn in the example, the foreshortening of the tiles is proportioned to that of parallel surfaces, such as the receding " treads " or tops of the steps. From the vanishing of their edges, we may judge these treads to be foreshortened about one half. Consequently lines parallel to the staircase edges (vanishing in VP1) must be foreshortened as much.

The tile adjacent to the lowest step is the best to begin with (since it is the same distance into the picture). As with the previous hexagons the rectangle ABCD is drawn first. And since much depends on the correctness of this first rectangle, it is worth while to

Fig. 198

126

take especial pains with it. Observe that as the tiles are here placed, it is the width (AD) of this rectangle which is parallel with the receding staircase edges. Thus these tiles are three and a half inches on their edges, making the rectangle width *actually* half the height of a seven-inch step. In the drawing this width, being foreshortened as

Fig. 199

much as the steps, appears only one fourth as wide as the height of the step. The actual length of the rectangle is seen by the diagram to be one eighth less than twice its

Fig. 200

width; or (what is the same thing) one eighth less than the height of the step. Being slightly turned away, it will appear a very little shorter in comparison than that. In this case it was made one sixth less than the height of the step.

END VIEW OF STEP

Fig. 201

It will be readily seen how if the rectangle proportions are right, the lines of this first hexagon, when carried out forward and back, will give points for the other tiles, making them fall harmoniously into their proper perspective.

Chapter *XXXIX*

THE HEXAGONAL PRISM AND FRAME

THIS exercise may be drawn from the objects, if they are at hand. If they cannot readily be had, the drawing may be made from these directions, using the cardboard plinth made for Chapter XXXVII. The objects should then be drawn from memory.

The Prism. — Being the simpler to draw, this object should be taken first, though it should be placed at the bottom of the sheet, on account of its greater horizontal dimensions.

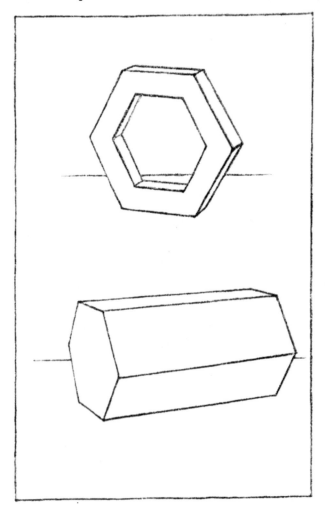

This model is eight inches long, and the diameter of its hexagonal bases is four inches. It is placed so that the bases make angles of sixty degrees with the picture plane. The

Fig. 202

128

dotted lines in Fig. 203 show how the cardboard plinth may be placed in the same position as a help in study.

The Nearest Vertical Hexagonal Base. — Sketch the construc‑ tive rectangle previously used, noting that its width is fore‑ shortened as much as the most foreshort‑ ened side of the cube in Chapter XVII. Set off the third diagonal of the hexagon (EF) perspectively on a line vanishing to VP1 through the rectangle center (as on page 124).

FIG. 203

The Long Edges of the Prism. — Take the direction of the nearest upper edge, giving VP2. Vanish the other long edges with it, and set off on the one first drawn its apparent length (AG). This can be easily estimated by re‑ calling the cube. That is, its *actual* length as given is twice that of the diameter of its base (the near vertical line AB). AG will therefore be as long as two cubes placed side to side.[1]

The Further Base. — For the horizontal top edge of the further base draw a line parallel to the same line in the near one (that is, vanishing in VP1), which gives GH. For the corner corre‑ sponding to B in the near base drop a vertical from G, giving J. The upper oblique edge (GI) is parallel to AF in the near base, and their vanishing point is OVP1, vertically above VP1. Another oblique line, from the nearest point, I, to the lowest, J, completes the prism.

FACE VIEW OF FRAME

SECTION OF FRAME

FIG. 204

The Hexagonal Frame. — This model is three inches on a side, and is one inch square in sec‑ tion (Fig. 204). It stands on one rectangular face with its hexagonal faces at an angle of thirty degrees with the picture plane (Fig. 205). For the outer hexagon and the outer thickness proceed as in the prism.

[1] This method is given in a slightly different form under Solutions of Problems, Chapter XVI.

For the inner hexagon we may first study the actual shape in Fig. 204, where it is seen that the vertical frame thickness can be conveniently carried across to measure it at Cy on the nearest vertical, BC. We know this thickness to be one inch, which is more than one sixth and less than one fifth of the vertical CB. If one fifth of CB (CO in Fig. 205) be found, and three quarters of this (Cy) be taken, it will serve the purpose. Mark the same distance from B up (point z). From these points (y and z) vanish the horizontal lines of this inner hexagon with their parallels to VP1. The corners of the inner hexagon are on the diagonals of the outer one, so the crossings of the diagonals

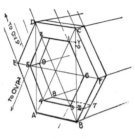

Fig. 205

by these two vanishing lines give four corners of the inner hexagon (1, 2, 3, and 4). From 2 an oblique line vanishes downward with its parallels to OVP2, marking point 5 on the horizontal diagonal EF. Another from 3, also vanishing in OVP2, is drawn from 3 upward to cut EF in point 6. Lines from 6 to 1 and from 2 to 5, complete the inner hexagon; and should, if the drawing is correct, vanish with those parallel to them in OVP1.

The inner edges of the thickness which are visible vanish from 4 and 5 to VP2, being parallel to the outer thickness edges. For the visible part of the further inner hexagon, a line of the near inner hexagon, as 4-3, may be carried "around the corner" and back, as in the square frame (Ch. XXIV). From the point where this vanishing line (7-8) cuts the line from 4 to VP2, an edge (8-9) vanishes with its parallels (CF and others) to OVP1. This point is even further away than OVP2, so that the convergence of its vanishing lines must be slighter. Where line 8-9 crosses the one from 5 to VP2 it meets the last visible edge of this back inner hexagon, a line vanishing in OVP2.

Chapter *XL*

THE TRIANGULAR PRISM AND FRAME —
PROBLEM FOR ORIGINAL STUDY

THE MODELS. — The prism is eight inches long, and its triangular ends are four inches on a side. The frame is six inches on a side, and one inch square in section. See diagrams, Fig. 206.

Positions. — The objects are placed four feet away, and one below the eye, and are separated, as were the models in the last chapter. The prism rests on one long face, with its long edges making angles of thirty degrees with the picture plane. The frame rests on a rectangular face with its triangular faces at thirty degrees with the picture plane.

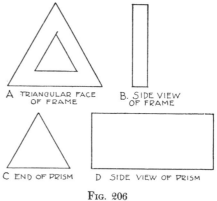

A TRIANGULAR FACE OF FRAME B. SIDE VIEW OF FRAME

C END OF PRISM D SIDE VIEW OF PRISM

FIG. 206

Arrangement on the Sheet. — The drawings are to be placed on one sheet. The position of the paper (whether with its long edges horizontal or vertical) and the placing of the drawings on the sheet must be such as to produce the most agreeable and satisfactory effect.

Chapter *XLI*

THE STUDY OF PARALLEL PERSPECTIVE

FROM Chapters XXXIV and XXXV it is seen that interiors follow the law of the cube. This, however, leads to what may seem an inconsistency. Why, it may be asked, does the table in Fig. 207 differ from the cube in Fig. 208? In the cube B was made shorter than A because farther into the picture. But in the table B was not drawn shorter than A.

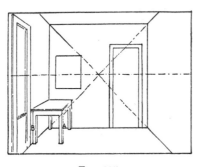

FIG. 207

The answer to this is that the table was not studied alone, as was the cube. It was part of a picture in which the dominant part (the back of the room) was parallel to the picture plane. Having drawn the side of the table parallel to the sides

FIG. 208

of the room, it is absurd (Fig. 209) to draw its end otherwise than parallel with the back of the room. Fig. 207 satisfies the eye and gives a true impression of the room and its contents. Could the room be erased, leaving the table alone, it would present the error shown in Fig. 210. Here it forms the whole picture and its picture plane makes an angle with its ends (see plan in Fig. 210), hence it must be drawn as below.

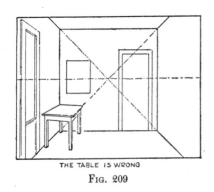

THE TABLE IS WRONG

FIG. 209

132

It is undeniable that in Fig. 207 B is farther *from the eye* than A. But since drawing that corner smaller produces the false impression seen in Fig. 209, we are guided by the distance of these points not from the eye, but *from the picture plane.* The picture plane simply forms the best means of attaining our fundamental object — a truthful representation. Hence the necessity of determining the limits of the picture (Fig. 211) and of clearly fixing in mind the central direction of seeing and the picture plane.

Under some conditions, surfaces may even be drawn in their true shape when not quite

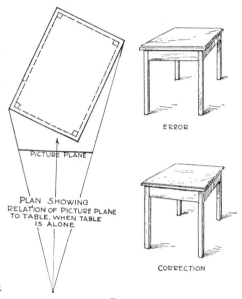

ERROR

PICTURE PLANE

PLAN SHOWING
RELATION OF PICTURE PLANE
TO TABLE, WHEN TABLE
IS ALONE

CORRECTION

FIG. 210

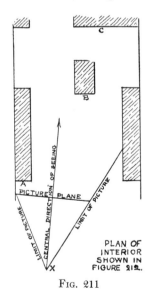

PLAN OF
INTERIOR
SHOWN IN
FIGURE 212.

FIG. 211

parallel to the picture plane. In Fig. 211 none of the vertical surfaces, as A, B, and C, are exactly parallel with the picture plane. In Fig. 212 this is shown by the convergence of the lines at right angles to these surfaces; their vanishing point being a little out of the center of the picture. Yet if all these vertical surfaces are drawn in perspective (A in Fig. 212) the result is misleading or impossible, and the eye protests. But the drawing is perfectly satisfactory in B, Fig. 212.

A convincing illustration of dominant surfaces parallel to the picture plane is the familiar form of a bureau. With an unbroken top (A in Fig. 213) it is easily drawn like the book and cube. If now the middle of the upper drawer is cut out, the

remaining small ones are seen to occupy positions similar to that of the table in Fig. 1.

The Street. — The street is another example of these conditions. Viewed from the middle of a crosswalk (x in plan, Fig. 214) the fronts of the houses present to the beholder a perspective like that of the interior in Fig. 207. They vanish to the center of the picture, and surfaces at right angles to them are drawn in their true shape. This is done even if the convergence is not

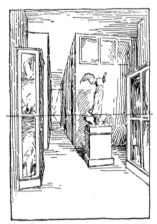

A Untrue Drawing OF VIEW FROM X, IN PLAN.

B Correct Drawing OF THE SAME VIEW.

toward the exact middle of the picture (Fig. 215), provided it does not fall to right or left of the house fronts. In this view, although the beholder has passed on to y, the conditions are still like those of the interior in Fig. 211.

But if instead of using both sides of the street for our picture, we choose one of the corners, the picture plane for this forms a different angle with the principal surfaces (Fig. 214), and the view must be drawn as shown in Fig. 216.

It may therefore be concluded, that *in any picture having a dominant part parallel with the picture plane and consequently drawn in its true shape, all portions of that picture which are parallel with the picture plane must also be drawn in their true shape.*

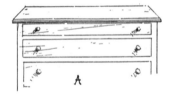
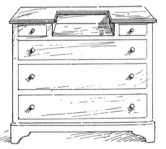

Fig. 213

Also, even such dominant parts as are not quite parallel with the picture plane must be drawn in their true shape *in certain cases where drawing them in perspective produces false or misleading results.* Finally, it is of great importance to include in the picture *only what can easily be seen.*

Parallel perspective, as work under such conditions is called, involves no departure in principle from freehand perspective in general. It is merely an adaptation of perspective methods to certain conditions in the subject.[1]

Space has been given here to a somewhat extended consideration of the subject,

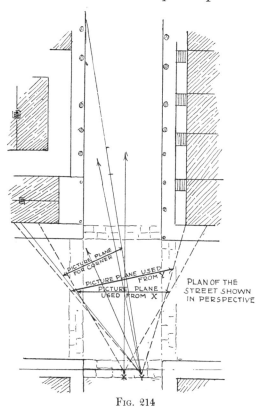

PLAN OF THE STREET SHOWN IN PERSPECTIVE

Fig. 214

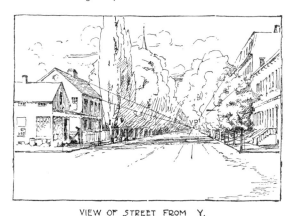

VIEW OF STREET FROM Y.

Fig. 215

[1] The terms " parallel " and " angular " perspective, though used for lack of better ones, are therefore far from satisfactory.

because the confusion concerning it that frequently exists is deemed unnecessary. It has been found that students may be easily led to distinguish when such conditions are present, after which there is no difficulty in dealing with them.

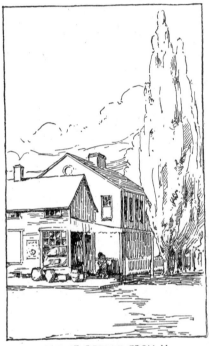

VIEW OF CORNER FROM Y

FIG. 216

Chapter *XLII*

A STREET FROM THE PHOTOGRAPH

THIS exercise (Fig. 217) may be drawn first if judged best, noting carefully the changes made in rendering from the photograph shown in Fig. 218. The student should then select a print of a street and make a drawing from it. All sketches should be thoroughly thought out, having the level of the eye carefully placed, and all the vanishing points located, either actually or mentally. It will probably be necessary to correct some distortions of the camera (see Ch. XLIII).

This drawing should be followed by studies from the street and from memory. Notes and sketches made

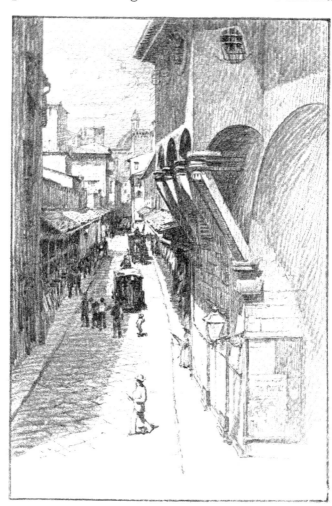

FIG. 217

A STREET FROM THE PHOTOGRAPH

by the student at the place chosen may be used to help this memory work.

FIG. 218

ENTRANCE TO THE PONTE VECCHIO, FLORENCE

Chapter *XLIII*

EXCEPTIONS TO THE USE OF THE FLAT PICTURE PLANE

I T will be observed that in photographs the circular tops of columns near the edges of the picture often appear as slanting ellipses (Fig. 219). And all who have an acquaintance with mechanical perspective will recall that in certain problems the ellipses of cylinders do not work out at right angles to the axis (Fig. 220). While the eye sees objects pictured on the inside of the spherical eyeball, the camera forms its pictures, and mechanical per-

FIG. 219
CLOISTERS OF THE MONASTERY OF SAN MARTINO, NAPLES

spective projects its problems on a flat surface. Therefore the camera cannot wholly reproduce objects as seen by the eye, and certain results obtained by mechanical perspective are untrue representations.[1]

[1] The photographic error has been recognized, and a camera is now made in which a clockwork attachment brings each part of the plate in turn directly facing the part of the subject it is to receive, and gives horizontal ellipses to columns wherever placed in the picture.

As for mechanical perspective, though useful in many cases, it has sometimes obscured the real aim of representative drawing.

CYLINDERS AS FOUND BY MECHANICAL PERSPECTIVE, SIDE CYLINDERS UNTRUE AS REPRESENTATIONS.

FIG. 220

It has even been taught that the flat picture plane should be used for all representative work as in mechanical perspective, logically to the end, regardless of any protest of the eye as to its results. To this error it is sufficient reply to say that the aim of freehand perspective is *the drawing of objects as they appear;* and that the eye never *sees* a column as in Fig. 219, nor a cylinder as the outer ones in Fig. 220. When, therefore, the use of the flat picture plane produces an untrue drawing, it is evident that an exception must be made in that case.

The Cylindrical Picture Plane. —Looking at Fig. 220, we find that the middle cylinder, which *does* appear right to the eye, extends equally each side of the central direction of seeing, so that the picture plane is parallel to the apparent breadth of the cylinder. By drawing the other cylinders as if each had such a central direction of seeing and such a picture plane of its own (A, Fig. 221) a result is obtained that appears true to the eye (B, Fig. 221).

In other words, *cylindrical objects, however placed, should be*

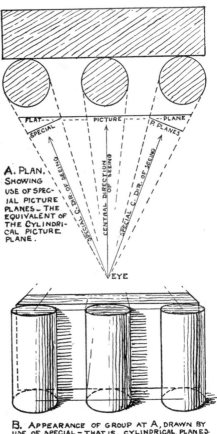

A. PLAN. SHOWING USE OF SPECIAL PICTURE PLANES—THE EQUIVALENT OF THE CYLINDRICAL PICTURE PLANE.

B. APPEARANCE OF GROUP AT A, DRAWN BY USE OF SPECIAL—THAT IS, CYLINDRICAL, PLANES.

FIG. 221

drawn as if for those objects alone, the picture plane was bent or rolled into a cylindrical picture plane. But this does not apply to the straight-line portions of the picture (as the block in Figs. 220 and 221), nor to the placing of the cylindrical parts, nor to their height. These must be determined in the ordinary way, by using the flat picture plane. We only abandon the flat picture plane where we cannot otherwise produce a representation which the eye will accept as true.

SIDE VIEW.
SHOWING THE USE OF PICTURE PLANES INCLINED FROM THE VERTICAL—THAT IS, USING THE SPHERICAL PICTURE PLANE.
FIG. 222

The Spherical Picture Plane. — Another exception occurs in a vertical direction. Thus, the only outline that will truthfully

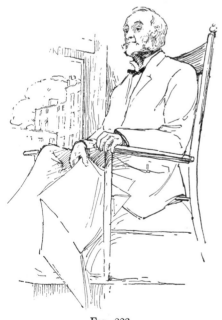

FIG. 223

represent a ball to the eye is a circle. To obtain that, we must regard its special central direction of seeing as directed to its middle, not only from side to side (as in case of the cylinder), but from top to bottom also. If the ball is above or below the eye therefore, its special picture plane is slanted accordingly (Fig. 222). In this case the picture plane (again *for such objects alone*) may be called a Spherical picture plane.

An example of its application is the case of a model posed higher than the student who is drawing (Fig. 223). The head is foreshortened vertically, and the forehead appears smaller in proportion than the lower and nearer features. At the same time the

window beyond that model is drawn on the usual flat picture plane; that is, with its vertical lines vertical, as always.

These distinctions will be found not only necessary, but natural and easy to make;[1] especially if care is taken to include in the picture space *only what the eye can see without noticeably moving the eyeballs* (Ch. XLI). The picture plane should be regarded as limited to what will cover this selected space, and we have no concern with what lies outside of that.

When working from a photograph therefore, as must often be done, such camera distortions as the columns in Fig. 219 should be corrected to agree with what is pictured by the eye. And in freehand work only such truths of mechanical perspective should be used as produce results which the eye confirms as true representations. Where the eye and a train of reasoning are in conflict, the reasoning should be scanned for errors. Unless a drawing *looks* right, it may safely be pronounced *not* right. It may look right, and still be wrong; but if the eye refuses to be satisfied, it is certainly wrong.

[1] So natural and easy, in fact, that space for this explanation is hardly needed, except to guard against false reasoning in the subject.

Chapter *XLIV*

SHADOWS

WHILE it is unnecessary for the mastery of freehand sketching to study this subject exhaustively, there are a few simple facts which have been found fundamentally useful in practice, and which may be easily understood.

Fig. 224

To that end the student should follow these explanations carefully, making experiments and sketches as needed. He should then compose and draw a group similar to Fig. 224, also should make other studies involving the use of the truths here developed.

Light may be regarded as composed of an infinite number of rays. From a lamp they extend outward in all directions,

forming what may be called a sphere of light. The shadow of the apple on the right of the lamp in Fig. 225 extends toward the

right; that of the book on the left in an almost opposite direction. The sun, on the contrary, is so much larger than the earth, and its rays have traveled such an inconceivable distance, that to us they are parallel, as are the paths of falling raindrops. Fig. 226

FIG. 225

illustrates this familiar truth. (This, of course, is also true of moonlight.) There are therefore *two classes of shadows:* those

cast by the sun, and those produced by near light, as a lamp. Under those formed by the sun may be studied first:

Small Objects in a Room. — If a shadow box be placed near and a little back of the window,[1] as shown in Fig. 227, the shadow edge (A–*b*) cast by the vertical box edge AB will lie on the

FIG. 226

floor of the box in a line actually parallel to that of the vertical hat-pin. The shadow of a vertical vase (Fig. 228) also casts a shadow in the same direction. (That is, line C, the shadow of its vertical axis will be parallel with the shadows of the vertical line AB on the box floor, and on the horizontal book cover.) The

[1] In this case the window is larger than the box; so that as far as the box is concerned the rays of light are parallel. As will be seen later in this chapter, the diffused light from a window causes radiating shadows in the room itself.

shadow (F*d*) of the vertical book corner (FD) will be parallel with these lines. If we push the box back or forward they all change direc-

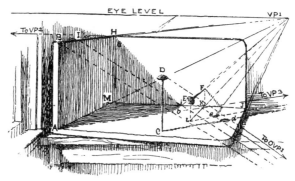

tion, becoming more nearly parallel with the picture plane as the box moves forward, and vanishing more steeply if we put it further back of the window. But they always

FIG. 227

remain actually parallel to each other.

In the same way we see in Fig. 227 that the shadow of the horizontal edge BH and of a horizontal hat-pin (EF) are actually parallel to each other, on both the back and the floor of the box. Also in Fig. 228 the shadow (*b–e*) falling on the hori-

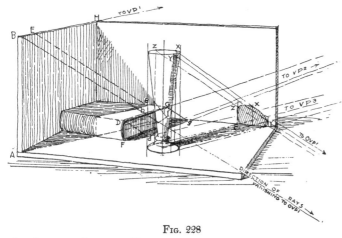

FIG. 228

zontal book cover from the horizontal box edge (BE) is parallel to the shadow (*d–g*) falling on the horizontal box surface from the horizontal line DG.

We may therefore say that the shadows of *actually parallel lines will lie actually parallel to each other on the same surface or on surfaces parallel with each other.*

But in perspective, parallel lines vanish; and if they are horizontal lines they vanish to the level of the eye. We should therefore expect these parallel shadows to also vanish thus, and we find they do vanish, in the same manner as any lines or objects.

We next observe (in Fig. 228) that the vertical vase casts a vertical shadow on the vertical back of the box. Then we recall that the horizontal edges BE and DG cast on horizontal

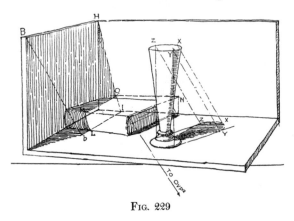

surfaces horizontal shadow edges *b–e* and *d–g*. As these edges vanish, their shadows vanish with them to the same point, as any parallel lines would.

It thus appears that *when the receiving surface is parallel to the object or line casting the*

FIG. 229

shadow, the shadow will also be parallel to the object or line.

This brings us to consider how to find the extent of shadows. If the shadow box is lowered from its usual place on the table to the floor, the shadows will be found shorter (Fig. 229). The light, falling more steeply, cuts off the shadows nearer the objects. When the box is lifted back to the table (Fig. 228) the

shadows will be seen to lengthen. With a light ruler or "straight-edge" (Fig. 230), take the actual direction from the hat-pin top (D) to its shadow (*d*) on the floor of the box. Keeping the ruler in the same actual direction, move it to

FIG. 230

the left till it grazes the top corner (B) of the box. It will be found also to mark the shadow (*b*) of point B.

The evident truth is that *the direction of the light-ray from any point in the object marks the same point in its shadow.* Therefore to find the shadow of any point, as of the other hat-pin head (E, Fig. 227) we have only to draw the light-ray from E to where it strikes the receiving surface.

But since in this case the window is nearer than the box, the

light-rays are receding slightly, hence must appear to converge
a little, like any parallel receding lines. Therefore to draw them,
we first find their vanishing point. Imagine one of these rays
(as D–d, Fig. 227) dropped vertically to the floor of the box (as
the gable edge in Ch. XXII was dropped). It would then lie
in the horizontal shadow line (C–d) directly under it, and would
vanish in VP3. When lifted again to its former oblique position
(D–d) its vanishing point would have moved down in a vertical line
from VP3, and become OVP1. All other light-rays in this illustra-
tion (as Bb and E–e) appear to converge to this vanishing point.

*How to find where the light ray and the receiving surface
meet is the next consideration.* In the
case of D–d we had a vertical line, DC,
and its shadow, C–d, cut by the light-ray,
D–d. From E we can imagine a vertical
line, similar to DC, dropped to the floor
of the box. (We can find where this

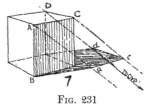

FIG. 231

vertical line will touch the floor by a vertical from F to the box
edge MJ at point K, and a vanishing line from VP1 through
that point, K, to cut the vertical from E, in L.) From L a line
actually parallel to the shadow C–d (vanishing in VP3) cuts the
light-ray in the desired point, e. This is essentially the way most
shadow points are found: — *by a vertical line from the point on the
object* to the receiving surface, *and from that a shadow line on the
receiving surface* to cut the light-ray. In other words we *pass an
imaginary vertical plane through the point and the light-ray.*
Fig. 231 shows a simple application of these principles. When
the cube has been drawn, the direction and length of the shadow
edge Ba may be assumed (or taken if drawing from the object).
This gives the direction of the light-ray A–a. The shadow a–c
vanishes with AC till cut by the light-ray from C, and c–d
vanishes with CD. These points can be tested by vanishing the
light-rays from the other corners to OVP1, thus completing the
several vertical planes as above mentioned.

The shadow of the left horizontal box edge (BH) falls partly

on the back of the box in a slanting line which may be thus determined. Take the book out (Fig. 227), when it will be seen that the near part of the shadow, beginning at *b*, vanishes on the floor of the box to VP1 till it reaches the box edge in point *i*. The shadow must start at H, hence H–*i* is the line in question. Many shadow lines can be found thus,— *by locating any two points in the line.*

Looking again at the shadow of the vase on the back of the box, we observe that the shadow of its horizontal circular top fall-

A. PLAN—SHOWING SYMMETRY OF SHADOW

B. PERSPECTIVE OF ABOVE.

FIG. 232

A. SHOWING A VERTICAL PLANE AT RIGHT ANGLES TO CENTER OF SHADOW

B PERSPECTIVE OF ABOVE.

C FACE VIEW OF VERTICAL PART OF SHADOW.

FIG. 233

ing on the back of the box is not a horizontal curve. To understand this, we will begin with the shadow of any vertical cylindrical object on a horizontal surface, as in Fig. 232. It will be found actually symmetrical. In perspective it will be foreshortened (B in Fig. 232); and lines marking its horizontal details (as AB, CD, and EF) will vanish, as would any parallel horizontal lines. If now we move this object toward a vertical surface, *placed so that, viewed from above it makes right angles with the light rays* (as shown in A, Fig. 233), *the shadow on the vertical surface*

also will be actually symmetrical; though it may *appear* fore-shortened (B in Fig. 233), as in this case.

Now if the receiving surface be turned so it is *not* at right angles (viewed from above) with the light (Fig. 234), we get what we observed in Fig. 228, — *an actually one-sided shadow.* The reason for this distortion is made clear from the plan in Fig. 234. The descending light-ray from *y* has farther to travel before striking the receiving surface, hence its shadow, *y*, is lower than the shadow from *z*. Such variations of original shapes are of the same nature in producing beauty (and consequent enjoyment) as theme

A. SHOWING VERTICAL PLANE AT UNEQUAL ANGLES TO SHADOW CENTER

B PERSPECTIVE OF ABOVE — SHADOW DISTORTED

FIG. 234

variations in music. Thus the bottle with shoulders (Fig. 235) acquires a charm from the proximity of its interestingly altered shadow-self which it cannot have alone.

FIG. 235

For the shadows of curves vertical planes through several points (as *x*, *y*, and *z*) are taken and the curve then sketched freehand. The use of this method is also shown in drawing the horizontal hat-pin in Fig. 227 and the the vase shadow in Fig. 228. But as soon as the underlying truths are clearly understood, the actual taking of points is seldom needed.

So far the shadows have fallen on flat surfaces, but the shadow of the vertical box edge in Fig. 228 falls partly on the curved book back; and on this it forms a vertical curve — that is, with its ends in a vertical line. The curve is sketched by the

eye, though it could be constructed by points. In Fig. 229 the shadow on the book back is cast by a horizontal edge and is

FIG. 236

therefore an oblique curve. In this case its upper point (M) is found by imagining the book cover continued until it cuts the back of the box in a line from N vanishing with the long box edges. Where the shadow line HI cuts this line (point *o*) will be the farther end of the shadow line on the book cover. This line will vanish in VP1, and where it cuts the upper edge of the book back will be M, the upper end of the curve.

The book in Fig. 236 shows the use of points *when the edge casting the shadow is itself oblique.* A vertical line from D to the

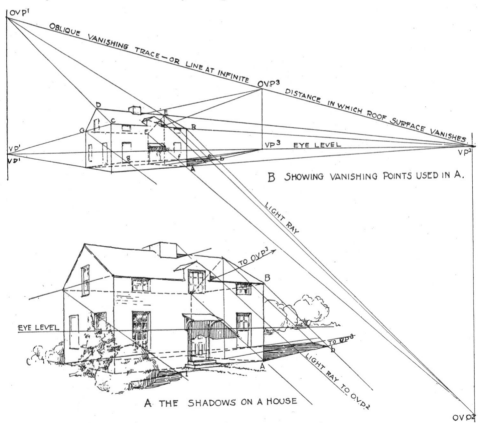

B SHOWING VANISHING POINTS USED IN A.

A THE SHADOWS ON A HOUSE

FIG. 237

edge 1–2, and a line from that point (E) to C, constructs one vertical plane. The light-ray from point A cuts the shadow-direction of AB at *a*. The shadow of CD travels from C through *a* to the edge 1–2, and from there to D.

Shadows on a House. — The truths thus developed apply to out-of-door work, as shown in the house (Fig. 237). Here one new condition is met, — the shadow of the vertical dormer edge falls on the oblique surface of the roof, and hence has an oblique vanishing point. This vanishing point is easily found, as we already have two points in the vanishing trace of the roof, — OVP1 and VP2. The line containing these

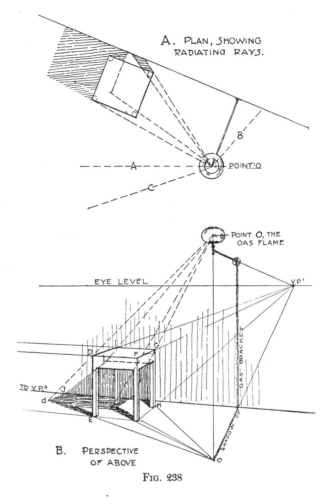

A. PLAN, SHOWING RADIATING RAYS.

B. PERSPECTIVE OF ABOVE

FIG. 238

points is the vanishing trace, not only of the roof, *but of the infinite plane containing the roof.* (It therefore can be drawn as long as needed, being really infinite in length.) So we have only to draw the trace from OVP1 to VP2, and mark OVP3 on it vertically over VP3, exactly as we marked OVP1 over VP1.

The shadow of the bush is an instance of the ease with which shadow laws are applied to natural objects. The shadow is sketched

freehand; but with much greater certainty for knowing that its center must fall on the ground in the direction of VP3, and that it can extend no farther than its meeting with the ray of light, HI.

Shadows from a Lamp. — The radiating rays from an artificial light can all be contained in an infinite number of radiating vertical planes through the light itself. Some of these radiating planes are seen in the plan (OA, OB and others in Fig. 238).

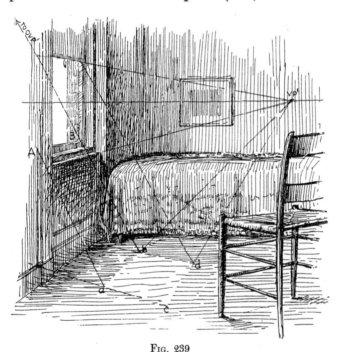

FIG. 239

These radiating planes are used instead of the parallel vertical planes previously explained. Otherwise the methods are the same as with light from the sun. Thus in the shadow of the stool the light-ray from O through D gives d where cut by a line on the ground directly under it (from o through E). The shadow of Gh falls on the floor in the direction of o–H till it reaches the wall. On the vertical wall, the shadow of the vertical GH is also vertical. It is ended by the light-ray from O through G. The shadow of the edge GI will be parallel to it, and like it will appear as a vanishing line to VP1. The near part (d–j) of the shadow of DI will be parallel to DI, and will vanish to VP1 till it reaches the wall at J. A line from J to I completes the shadow of DI.

Shadows in an Interior. — These are partly like the lamp shadows. For instance the shadow on the couch in Fig. 239

152

extends in an almost opposite direction from that of the chair. These shadows are produced by the diffused daylight radiating from the window. On the other hand a patch of sunlight falling through the window would follow the laws of sunlight generally. The edges *a–b* and *c–d* vanish with AB and CD, while points *a* and *b* are marked by the meeting of light-rays from A and B with shadows of verticals from A and B. In this case the light comes from beyond the window, hence the light-rays recede up, and appear to converge or vanish in that direction.

Chapter *XLV*

OUT-OF-DOORS WORK

ALTHOUGH the same perspective principles apply to out-of-doors work the conditions of the study vary, and some cases need explanation.

Vanishing Points. — In drawing the house (Ch. XXII), we placed ourselves proportionately in relation to the small cube as we should naturally be in relation to the real house. Thus the sixteen inches of distance from the eye, or four times the

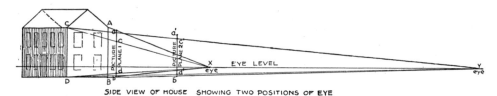

SIDE VIEW OF HOUSE SHOWING TWO POSITIONS OF EYE

FIG. 240

height of the cube, was equivalent to only four times the height of a twenty-foot house, or eighty feet — less than five rods. At this short distance the vanishing of the lines is very decided ; but at a half mile from the same house, those lines appear nearly horizontal. The reason for it is seen in Fig. 240. When the eye is near the house (at *x*) the apparent difference in length between the edges AB and CD is greater than when the eye is at *y*. This is shown on picture plane 1 by *ab* and *cd*, and on picture plane 2 by *a'b'* and *c'd'*. The horizontal edges of the house as seen by the eye from *x* would therefore vanish more steeply, causing the vanishing point to fall nearer, as shown in A, Fig. 241. As seen from *y*, the horizontal edges are less steep; therefore in B the vanishing points fall much farther away.

It follows, therefore, that *the greater the distance of the eye*

from an object, the farther to right and left will the vanishing points fall. When the house is a half mile away they fall so far to left and right that its horizontal lines appear almost level. Hence the beginner in landscape work, accustomed only to near objects, is sometimes puzzled, because distant houses seem to have no perspective. And the landscape artist who has "no

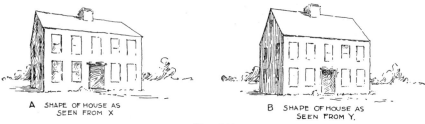

A SHAPE OF HOUSE AS
 SEEN FROM X

B SHAPE OF HOUSE AS
 SEEN FROM Y.

Fig. 241

trouble with houses" *in the distance* may shrink from attempting them in the foreground.

Size of Objects Seen. — The image formed on the retina of the eye is always exceedingly small, and with distant objects becomes microscopic. All mental picturing of the size of objects proceeds from our mental *knowledge* of their actual dimensions. Size judged from seeing alone can be but a matter of comparison. This is easily proved by asking two persons how large the moon appears to them. Here we have an object whose real size and distance are so great as to be no guide in comparison with other objects and it will probably appear of a different size to each person. There is consequently no such thing as the drawing of objects "the size they appear." *Size in drawing is merely relative; and the scale on which a drawing is made is wholly a matter of choice.* We may choose to make a drawing what is termed "actual size," but this means that we regulate its size by a mental knowledge obtained either from measuring in the ordinary way, or by putting our sketch back by the object to compare them by the eye.

The absolute size of objects varies so much, also, that unless the picture contains something the size of which is well known

and but little variable, we cannot be sure of the sizes repre-
sented. The human fig-
ure serves best for such
a standard, but some
objects always adjusted
to the human figure in
size, as steps, and often
doors, will answer in its
place.

*The size of objects ac-
cording to their distance
into the picture* is impor-
tant in out-of-doors work
also. Here the indis-
pensable picture plane
becomes again useful.
In Fig. 242, for instance,
the gondolier must not
be too large for the
buildings. Lines drawn
from his head and a
point on the water di-

rectly under it to the eye level will contain between them his
height above the water
all the way to their van-
ishing point. If we
wish to know, for in-
stance, whether the door
on the left is large
enough, we have only
to draw horizontal lines
from its top and from a
point directly under it on
the plane of the water

continued. Where this water line would cut the water line from

the figure to the vanishing point a vertical line is erected, on which the two heights can be compared.

Reflections. — If a mirror be laid on a table, and a cup placed on it (Fig. 243), the reflection will appear precisely like the cup reversed, with its bottom resting against the bottom of the real cup. The reflection will not present to the eye the same shape as the real cup, for besides being reversed it is farther below the eye, making its inside invisible while its base is covered by that of the real cup. We can also see farther around on its flaring

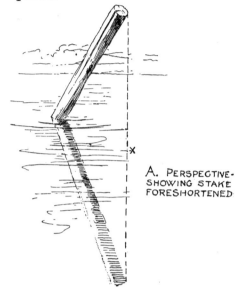

A. PERSPECTIVE-
SHOWING STAKE
FORESHORTENED

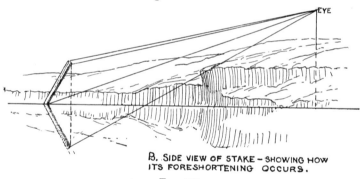

B. SIDE VIEW OF STAKE – SHOWING HOW
ITS FORESHORTENING OCCURS.

FIG. 244

surface, because its decrease of diameter is toward the eye level, while in the actual object it is away from the eye level.

Now since it is like the cup reversed we see that any point (as A) in the cup, must be reflected directly under itself. So a stake, thrust into a pool of still water (Fig. 244), will produce a reflection like itself reversed;[1] and each point in the reflection will be directly under the same point in the real stake.

[1] In this case *appearing longer* than the real stake, as explained a few pages later.

It is therefore evident that *in case of reflections on a horizontal surface, the image formed must be vertically under the reality.*

Consequently, as long as the reflecting surface remains horizontal, reflections on it cannot be thrown to one side, but must be shown directly under the real objects, even if the reflecting surface be broken (as in Fig. 242). And if in drawing reflections we represent them out of the vertical (Fig. 245) the reflecting surface (in this case the water) appears to be sloping, like rapids in a river. We may therefore take as our rule that *reflections are invariably like the reflected object reversed on the reflecting plane.*

WRONG. REFLECTIONS NOT VERTICALLY UNDER OBJECTS REFLECTED. WATER APPEARS SLOPING – NOT LEVEL.

FIG. 245

When the Object is Separated from the Reflecting Surface. — In Fig. 246 the bungalow is separated from the reflecting

The bungalow is estimated to be this distance (E F) further into the picture than the boathouse.

FIG. 246

surface (the water) by a high bank. But by using a water line of the boathouse (which stands parallel to it and directly on the water), the points (A, B, and C) where the bungalow edges continued would strike the plane of the water can be closely approximated. From there the points (a, b, c, and d) for the reflection of the bungalow are measured vertically.

Even if we had not the boathouse to give parallel vanishing lines on the water, the necessary points (A, B, and C) could be estimated with sufficient accuracy after a little experience. The main thing to remember is that it is on the reflecting surface *or on its plane continued* that the object is reversed in its reflection.

Reflections on Vertical Surfaces. — With reflections on vertical surfaces the problem is very simple. In Fig. 247 the box appears reversed as far back of the mirror surface (the thickness of its frame) as it actually stands in front of it.

FIG. 247

Length of the Reflection. — The vertical length of the reflection, while the reflecting surface is unbroken (as in Fig. 243) is actually the same as that of the real subject. This does not mean that the reflection will always *appear* of the same vertical length as the object, as that depends on its position and on the location of the point from which it is viewed. In Fig. 244 the stake is seen from a higher point and leans toward the beholder. It is consequently seen foreshortened, as the roundness of its top indicates. The reflection, being reversed, appears practically in its true length. A point (x) on the surface of the water directly under the top, appears lower than where the stake enters the water, because nearer the eye. Cases like the familiar " silver

path" of the moon in rippling water, or like Fig. 242, where the reflections of upright objects appear lengthened vertically as well as broken, are caused by the many curved surfaces of the waves on which successive bits of the reflection fall.

Use of the Finder. — Nowhere will the finder (Ch. VIII) be of more use than in out-of-doors work. The difference in distance between the near and far objects in a landscape is so great, that the beginner finds it hard to realize how much difference he must make in size. The finder serves as a measuring unit for these differences, besides being invaluable as an aid in selection.

SOLUTIONS OF PROBLEMS

CHAPTER XI — PAGE 34

THE CYLINDER CONE AND BALL

THE **Cone.** — After the cylinder is drawn, the base of the cone is next placed. This is actually a circle, and of the same size as the cylinder base. Its position will be clear from the plan (Fig. 249, p. 34). In perspective it is best placed by its true center. If the cone were moved on the ground around and touching the cylinder, this center would describe a circle, twice the diameter of the cylinder base, and equally distant at every point from the cylinder. This circle is sketched in perspective (Fig. 250) as an ellipse (see Chs. IV and XX). The true center for the base of the cone is placed on this ellipse (at O). From this true center a ver-

Fig. 248

161

tical line of indefinite length may be erected, on which to set off the axis of the cone. Its height, being actually the same as that of the cylinder, will appear slightly greater because nearer the eye. At the

FIG. 249

same time its apex (F), being nearer, cannot appear quite so high on the paper as even the nearest edge of the cylinder top.[1] Through its lower end (O) the *real diameter* of its circular base passes. Being at the same distance into the picture as the axis, and like it parallel with the picture plane, it appears in its true proportion to the axis (one half). It is therefore so set off, equally on each side of O, giving AB. If right, this true diameter should measure a little greater than the diameter of the cylinder. The base of the cone, though actually of the same size as the cylinder, will *appear* both

a little larger and a little rounder, because nearer. The short diameter of this base (CD) is therefore set off greater than that of the cylinder base, remembering that as O is the *real* center, DO must be larger than CO. The long diameter (the light line in front of AB) is next drawn, exactly in the middle of CD and a very little longer than AB. The ellipse is then sketched through the

FIG. 250

four points A, B, C, and D, taking care to have it touch the base of the cylinder, and to make the greatest length *not* on AB, but on the long diameter. The cone is completed by drawing its sides from the apex tangentially to this elliptical base.

The Ball. — If the ball be rolled about and touching the cylinder it will follow the same path as the center of the cone base, so that its resting point will always be somewhere in the ellipse representing that path (its center being always vertically above the resting point). We should therefore mark some point in the large ellipse (in this case *x*) for the resting point of the ball. If we stoop to bring the eye nearly

[1] Being *actually* of the same height, they lie in the same horizontal plane. This plane, being below the level of the eye, appears to recede upward, as the table does. This will be better understood if a sheet of paper is laid on the tops of the two objects, when it can be seen that it appears to recede upward. The following chapter will further illustrate this truth.

to the table level, and look at the ball, we shall see it resting on this spot. But if we return to the point from which the group was to be viewed, we shall find this point hidden by the projecting mass of the ball. The circle which represents the boundary of the ball is therefore drawn with its lower edge a little below x, and its center vertically over that point. Being nearer the eye, its diameter is greater than AB.

CHAPTER XV

THE CYLINDER AND THE RECTANGULAR BLOCK — PAGE 48

The Block. — This should be drawn first. Since its front face is parallel with the picture plane, it will appear in its true shape, and the block ends will vanish in VP1 like the book ends in Chapter XII. In setting off the apparent width of the top, we remember that it is actually narrower in proportion than the book cover.

The Cylinder. — The cylinder rests against this block (side view, Fig. 252), so we can measure the height of its back (AB, Fig. 253) actually, making it twice the height of the block

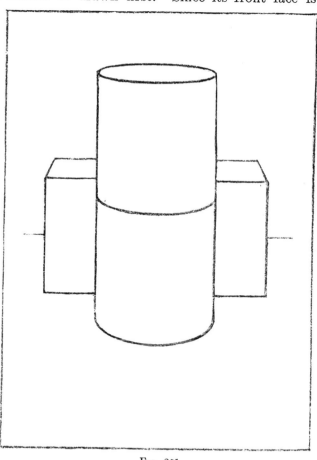

Fig. 251

front. The lower base is actually the same in width as the block, but being nearer the eye it will appear larger. Just how much can be easily determined. Draw the invisible lines of the block (the dotted lines in Fig. 253), and carry the diagonal of one half (x) forward in a line of indefinite length. Cut this by line y of the invisible edge of the block. From the point (C) so found draw line z to the right, to cut another invisi-

SIDE VIEW OF GROUP.
FIG. 252

FIG. 253

ble edge continued. This constructs another rectangle the actual size of the side of the block, but nearer, hence appearing larger.[1] The middle of the front of this rectangle (point D) will be the front of the base of the cylinder. Its back will be A, and its long diameter, EF, can be set off on a line sketched half way between this front and back, marking E and F half way between AD and the ends of the construction rectangle. Through these four points the bottom ellipse is drawn.

For the top ellipse a similar rectangle can be constructed directly above it. This will give a much more foreshortened ellipse, as would be expected. The back and front of the middle ellipse are drawn as directed in Chapter IV.

CHAPTER XXVI—PAGE 91

THE SQUARE FRAME LEANING ON A REC-
TANGULAR BLOCK

The Rectangular Block. — This solid is drawn in the same manner as the book similarly placed. Recall that it is equal to two cubes, as shown in Fig. 255, where a diagonal (AB) of the horizontal top face

[1] This use of the diagonal for measuring will be found in Chapters XXII, XXV, and others.

of the first cube is carried to its vanishing point VP3, from which a perspectively parallel line is drawn back to C, cutting the back edge

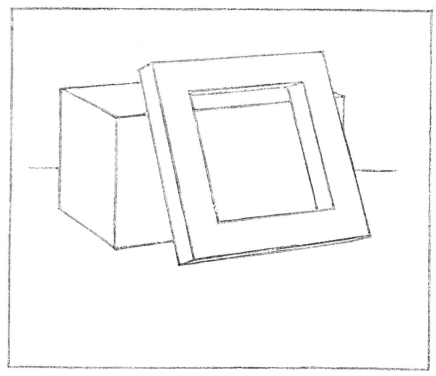

Fig. 254

in D, which becomes the farthest corner of the second cube, and of the whole block. A line through D, vanishing in VP1 gives the corner E.

The Frame. — For this *the lower face only* may be first considered. This face rests on AE in points one eighth of AE from either end, which can be easily found

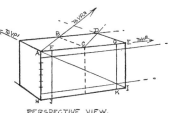

PERSPECTIVE VIEW.
THE LINES A B and C D
ARE ACTUALLY PARALLEL
AND VANISH IN VP3.

Fig. 255

by the method used on page 79 for the steps. (The vertical edge AH is divided into eighths, and lines from points 1 and 2 vanished to VP2. Where they cross the diagonal A1 verticals are erected, marking points F and G.)

Now by placing a card against one of the side thicknesses of the

frame (Fig. 255) we readily see that these thicknesses are vertical, and that their vertical planes (one of which is indicated by the card) are parallel to the block ends, and cut the block side A E I H in vertical lines (FJ and GK, already drawn), and also cut the ground in horizontal lines through J and K, parallel to the horizontal lines of the block ends. In these horizontal ground lines rest the lower corners of the leaning frame. We therefore vanish the lines through J and K to VP1, continuing them forward indefinitely. The distance JL (Fig. 257) is actually equal to half the block width; that is, to J3, and can be easily measured by a line through J parallel to H3 (vanishing with it to VP4). From where this line meets the continuation of the edge HN (in point 4) a line parallel to HI (vanishing in VP2) gives the corners L and M, and the ground edge of the frame.

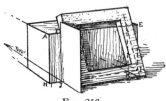

FIG. 256

The leaning edges of the square are drawn from L and M through F and G, and will be found to vanish in OVP1. They vanish a little less (have a more distant vanishing point) than the horizontal edge LM, and should therefore be made slightly longer, but shorter than if standing erect from L. We can check our estimate by comparison with LO, the height of the frame at that point (EH). To obtain this, the height of the block at J is carried forward to P on the vertical (by lines vanishing in VP1) and one half of LP added at the top, making LO.

The Thickness Edges. — These edges must vanish sharply (or have a near vanishing point) because the edges at right angles to them (the ones to OVP1) are foreshortened but little. Hence OVP2 is placed but little below the group.

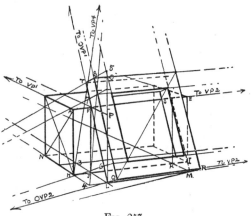

FIG. 257

To this point these short edges are drawn,

carrying them forward of the corners indefinitely for a short distance. The foreshortening of these edges (actually one sixth of the long edges of the square) will be much greater than that of the long edges; and a corner is marked accordingly at Q. From this corner a horizontal edge vanishes to VP2, and a long oblique one to OVP1, giving respectively R and S where each crosses a thickness edge. From S the other horizontal

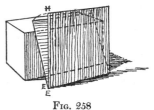

FIG. 258

edge vanishes to VP2 and from R the other long oblique one to OVP1, completing the square.

END VIEW OF GROUP.
THE LINES WHICH IN FIG 257
VANISH IN OVP2 ARE HERE SEEN
TO BE ACTUALLY PARALLEL.

FIG. 259

The Inner Square. — This is drawn as on page 86. The frame width can be measured perspectively on LT by continuing the edge TS to cut the continuation of LO in point 6, dividing L5 into six actually equal parts and vanishing lines to OVP2 from the first and last of these division points, giving 6 and 7, the points needed.

CHAPTER XXXI
PAGE 102
THE CLOCK

THE dial of the clock is expressed by the methods used for the circular frame in the square frame (Ch. XIX). After the rectangular portion of the clock has been sketched, an enclosing square for the dial (AB CD) is drawn and the clock axis vanished from the actual center of this square. The axis is continued forward indefinitely (upward to left) to give the direction of the short di-

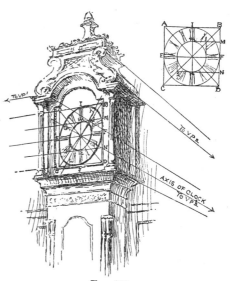

FIG. 260

ameter (which always *appears* to lie in line with the axis, though actually at right angles to it — p. 97, Fig. 160). For the ends (G and H)

of the short diameter, slightly curved lines are sketched up to the right from E and in reverse direction from F, giving the front and back of the ellipse. The long diameter is then sketched, of an indefinite length, midway between G and H and at right angles to the axis. It is then cut by curves from I to the right, and from J to the left, being careful to keep K and L equally distant from the axis. The remainder of the ellipse may then be drawn, correcting the curves as needed; and even moving K and L if necessary for symmetry, but not changing points E, F, I or J. The inner ellipse is drawn in the same way, as explained on page 98.

CHAPTER XL — PAGE 131
THE TRIANGULAR PRISM AND FRAME

The Triangular Frame. — This solid is easily constructed by the use of the cube (see dotted lines). The length of AC is found by the diagonal (ED) of one side of this imaginary cube, DF being made equal to DG (p. 165). The steps in Chapter XXII illustrate this method. The end view shows how the triangle is related in shape to the square face of the cube. Its vertical center line is located by the diagonals of the square, and the height of its apex is measured to x on the near vertical edge of the cube (AE).

The Triangular Frame. — This is also readily drawn

Fig. 261

by the help of one face of the cube. After the triangular outline is sketched, the height of one lower bar (one sixth of the height of the cube) is marked upward from C, giving point E, and the lower edge of the inner triangle is vanished through E. Where BF, drawn so as to divide AD perspectively, crosses this lower edge is a corner of the inner triangle.

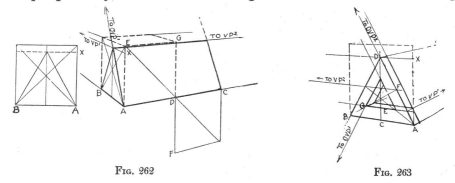

FIG. 262 FIG. 263

Through this corner (G) another edge of the inner triangle vanishes to OVP1. The other edge is drawn toward OVP2. The thicknesses are found as in the square frame (Ch. XXIV).

INDEX

INDEX

INDEX

INDEX

INDEX